Kakiemon

FAMOUS CERAMICS OF JAPAN 5

Kakiemon

Takeshi Nagatake

KODANSHA INTERNATIONAL LTD.
Tokyo, New York, San Francisco

distributed in the United States by Kodansha International/USA, Ltd.,
through Harper & Row, Publishers, Inc., 10 East 53rd Street,
New York, New York 10022

published by Kodansha International Ltd., 12–21 Otowa 2-chome,
Bunkyo-ku, Tokyo 112 and Kodansha International/USA, Ltd., 10 East
53rd Street, New York, New York 10022 and 44 Montgomery Street,
San Francisco, California 94104

LCC 80–84463
ISBN 0–87011–478–6
JBC 1072–789651–2361

Kakiemon

Study of the history of early Japanese arts and crafts reveals the direct influence of Silla and Koryo Korean styles and the indirect absorption of Chinese styles during the Nara and Heian periods (seventh to twelfth centuries). Muromachi period (1333–1573) crafts directly reflected Chinese styles of the Song (Sung) dynasty and indirectly were influenced by Korean styles of the early Yi dynasty (1393–1911). In the Momoyama period (1573–1615), Japanese crafts were given impetus by middle Yi and also European styles. In the early Edo period (1615–1868), Japanese arts and crafts were directly influenced by and received inspiration from Ming and early Chinese Qing (Ch'ing) styles before developing Japanese characteristics, which, in turn, reflected the social conditions of the time. All the arts and crafts—pottery, lacquer ware, textiles, etc.—mutually influenced one another. The Edo period style was both lyrical and lucid and clearly was part of the vigorous culture of that time.

Ceramics, whose production was greatly limited before about 1600, saw an explosive growth in the Edo period. Not only was there a radical development of techniques and improvement of quality, but a flourishing export trade existed as well as an active domestic market. Edo period crafts as a whole flourished because of the development of a commercial system, the activities of naturalized foreign craftsmen, the use of new materials and the introduction of new techniques, and the spread of family industries.

Ceramic production, in particular, was stimulated by the arrival of groups of potters from Korea at the turn of the sixteenth century as a result of Toyotomi Hideyoshi's military adventures on the Korean peninsula from 1592 to 98. These potters were responsible for the founding and expansion of kilns, for cooperation between kilns, and for establishing pottery as a domestic industry rather than as a subsidiary occupation of agriculture, as it had hitherto been. These potters also established the domestic porcelain production, which had not existed in Japan before this time. Deposits of kaolin were discovered, and the production of porcelain wares progressed rapidly under the patronage and protection of daimyo.

The next event of importance after the discovery of porcelain clay was that the Chinese techniques of enameled porcelain of the late Ming period were introduced directly to Japan around the end of the Kan'ei era (1643). Enameled porcelain occupied a central role in Japanese ceramic art of the Edo period. What is remarkable in view of the social conditions prevailing at that time is that these two epoch-making technical innovations (i.e., the discovery of kaolin clay and the use of overglaze enamel decoration) both took place in remote Arita County, located in the northwest of Kyushu. Thus, while Seto had been the center of Japanese pottery production until Edo times, Arita took over a substantial part of this role in the Edo period. The creation of porcelain wares, together with the perfection of enameled overglazing, was responsible for the development of an industry of great potential.

The Japanese terminology for overglaze-enameled pottery and porcelain is perhaps confusing—the terms *aka-e* (literally, "red painting"), *iro-e* ("color painting"), and *uwa-e* ("overpainting") are all used to refer to this type of ware. These terms may be used slightly differently by different scholars and craftsmen, but such niceties need not concern us here.

The history of Japanese enameled porcelain, from the time of its first successful firing through its various stages of progress until it came to be marketed both at home and abroad, should be seen within the context of Japan's cultural history. As mentioned above, Japanese arts and crafts once reflected Chinese influences via a sort of inverted "L"-shaped route through the Korean peninsula, and such influences were naturally modified in the process. With Japanese *aka-e*, however, it is important to note that forms,

designs, and techniques of decoration and firing were all imported directly from China. It is necessary to study the historical process in which the earlier fixed China-Korea-Japan route was replaced by a direct link to China.

Japanese *aka-e* is classifiable roughly into Hizen, Kaga (Kutani), and Kyō (Kyoto) styles. Both the wares of Hizen and Kutani use a porcelain body, while *Kyō aka-e* enamel is on a relatively low-fired pottery body. Porcelain was a late introduction into Kyoto ceramics.

The Hizen kilns were geographically located to allow the direct influence of Chinese enameled porcelain techniques. Furthermore, the nearby ports of Imari, Hirado, and Dejima provided convenient bases for overseas trade and domestic trade. The kilns of Arita manufactured high-quality wares on a semimass-production basis and thrived uninterruptedly during the Edo period under the patronage of the Nabeshima fief.

The enameled porcelain of Kutani is unusual in that, while kilns were located in the Daishōji domain, they were supported by the wealth of the neighboring Kaga fief and were indirectly influenced by the urban culture of Kyoto. There are various different theories about the origin of Kutani ware. I personally believe that this ware originated during the Meireki era (1655–58). The kilns then went out of production during the Genroku era (1688–1704) and were revived during the Bunka era (1804–18), in the late Edo period. Wares from the first kilns are now called Ko Kutani (Old Kutani), while those from subsequent periods of production are simply known as Kutani.

Because Kyoto enamel-decorated wares use pottery rather than porcelain, the ground color of the pots is usually a soft eggshell white or cream, rather than the porcelain white. Based upon a long tradition of aristocratic taste centering on the imperial court, Kyoto wares boast a comfortable and graceful charm. Despite its somewhat low market value, Kyoto *aka-e* is extremely artistic.

Edo period Hizen porcelain is highly marketable and at the same time is characterized by a noble beauty comparable to the work of such Kyoto master potters as Ninsei, Kenzan, Eisen, and Mokubei. In an odd parallel with the three major types of Japanese enamel-decorated ceramics, Hizen porcelain had three styles that formed mutually influencing traditions.

The Perfection of Early Aka-e

There is as yet no conclusive theory about the development of early Japanese enameled porcelain. Recently the assertion that *aka-e* was perfected by Kakiemon I has been questioned; this challenge does not, however, go beyond raising problems for future study. Neither has any reliable literary evidence been discovered to deny the traditional belief that Kakiemon I succeeded, late in the Kan'ei (1624–44) or early in the Shōhō (1644–48) era, in making the first enameled porcelain in Japan under the guidance of a Chinese potter.

What I would like to do here is summarize the accepted "Kakiemon theory" with regard to the establishment of Japanese *aka-e* before presenting my ideas about certain problems concerning Kakiemon's success in this field. In particular, I will discuss the kiln that was active in Nangawara-yama in Arita.

In *Kakiemon*, edited by the Kakiemon Research Committee (1957), and *Old Imari*, edited by the Old Imari Research Committee (1959), I published nearly all the passages from old documents that had the slightest connection with the creation of Hizen porcelain and the establishment of *aka-e* by Kakiemon. At the time I went no further than to introduce them as research materials. The extracts from old documents that I published in the two books have been discussed from various viewpoints, and I feel I fulfilled my responsibility as the matter stood at the time. In some respects, I owe an apology to the Sakaida Kakiemon family, but I do not regret having published the family's old records, which I had studied for twenty years. My publication of extracts from the *Sarayama Daikan kyūki* ("Records of the Office in Charge of Porcelain Kilns") in the Nabeshima archives and of all the old records preserved by the Sakaida family through the early, middle, and late Edo period formed, in effect, the basis of my study of the lineage and beauty of Kakiemon wares. I wish to emphasize again here that these records are precious materials for the study of the Kakiemon tradition. One has to be extremely precise in such research, to be prepared to accept one thing and deny another forthrightly. It is only in this way that one can rediscover the importance of the Kakiemon tradition and the characteristics of its beauty.

The belief ascribing the origin of Japanese *aka-e* to Sakaida Kakiemon I has been transmitted over the centuries. As seen from the vantage of the present, the following data are the basis of this belief (viz.,

1) A man who helped behind the scenes in the creation of *aka-e* porcelain was Higashijima Tokuzaemon, a pottery dealer in Imari, who was a good friend of Yamamoto Jin'emon, a retainer of the Nabeshima fief and the official clan supervisor of ceramic production at Arita Sarayama at the time (1648). He purchased overglaze enamel materials from a Chinese merchant at Nagasaki and supplied them to Sakaida Kizaemon (or Sōemon), with whom he had business relations, in the hope that Sakaida could produce enameled porcelain in Higo.

2) Sakaida Kizaemon (Sōemon)—that is, Kakiemon I—who is believed to have played a leading part in the creation of *aka-e*, was a *kama-nushi* (kiln owner) of some artistic taste, through not himself a potter or painter or craftsman. A close friend of the ceramic dealer Tokuzaemon, he was much attracted by Ming dynasty Chinese *aka-e* and is thought to have collaborated with Tokuzaemon in the establishment of *aka-e* techniques in Arita.

3) The Sakaida family at Nangawara-yama in Arita County descended from a high-ranking samurai of neighboring Chikugo Province. It is a timehonored family closely associated with the Higuchi, Baba, and Doi families, all of which moved during the Tenshō era (1573–92) from Sakaida Village, Kōsuma County in Chikugo to the Saga fief in Hizen Province.

4) The "Kakiemon" workshop appears to have been managed jointly by the Sakaida family and its relatives and was not Kakiemon's own individual enterprise. It seems that Kizaemon (Sōemon) and his father, Ensei, acted as representatives of the family as a whole and were responsible for running the workshop in their capacity as *kama-nushi*. It was customary that the names of craftsmen and other employees were never recorded alongside those of the *kama-nushi*; only kiln owners' names were mentioned.

5) There are some scholars who declare that *aka-e* porcelain wares from the Kakiemon kiln were not made earlier than the middle Edo period. However, a letter to Sakaida Kakiemon dated November 8, 1685, and signed by the Saga clan official Ōishi Gumpei, which may be regarded as a semiofficial document, has the following passage; "Furthermore, there is no doubt that *aka-e nishiki-de* (polychrome enameled porcelain) has been originated by you. You are therefore permitted to continue your trade for-

ever in this field. You should be grateful to our lord." The statement clarifies the fact that the Kakiemon kiln produced *aka-e* enameled wares and reveals how it received its position as such. The letter is dated ten years after the clan's official workshop moved in 1675 from Nangawara-yama to Ōkawachi-yama.

6) The *Kōgi on-yakimonokata oboe* ("Memorandum from the Official in Charge of Ceramics") inventories: "one *hon-gama* [glaze-firing kiln]; one *kara-usu* [clay pounding] shed; one *odōgu-ya* [storehouse for kiln equipment]; two *kara-usu* [clay pounders]; two large carts; one *aka-e gama* [enamel-firing kiln]; five bales of rice; two hundred *momme* of silver. . . ." and is signed by the clan officials O (unclear) Kakuzaemon and Yamada Zengoemon, and addressed to "Sakaida Kakiemon" (note the use of the Kakiemon name). This document makes possible a guess as to the situation of the Kakiemon kiln around 1680.

The Lineage of the Kakiemon Family

It is said that the Sakaida family moved to the Nangawara-yama area in Arita County around 1615, after the summer siege of Osaka Castle. The family earlier had been engaged in the manufacture of *kawarake* (unglazed earthenware) at Shiraishi Village (now Ariake Town, Kishima County) facing the Ariake Sea. It is also said that at the outset after its move to the Nangawara-yama area, the family made stoneware (perhaps somewhere around the Tenjin-mori kiln) and began to make porcelain at the end of the Genna (1623) or beginning of Kan'ei (1624) eras. Sakaida Ensei (father of Kakiemon I) was the head of the family at the time and seems to have been friendly with Gensō Tojaku, the eminent Buddhist priest at the Shōten-ji temple in Hakata.

It was perhaps during the time of Ensei's son, Sakaida Kizaemon (Sōemon), that the family became the *kama-nushi* of a fully equipped ceramic workshop. Details of the early Kakiemon period, represented by Kakiemon I, II, and III, can be known to some extent from inscriptions on tombstones in the Lower Graveyard (at Shimo Nangawara, near Seiroku no Tsuji) and the Upper Graveyard (on the hill near Kami Nangawara) of the Sakaida Kakiemon family. There is a recent trend among certain scholars to try to disprove the pedigree of early Kakiemons by adding irrelevant epitaphs and posthumous Buddhist names to the necrological listing, instead of taking the

trouble to visit the graves and find out the truth for themselves. Such interpretations are, however, both groundless and farfetched.

The middle Kakiemon period (middle Edo period, around the Genroku era) was an eventful, transitional period in which there was an interchange between the pure Imari and Kakiemon styles. During this time, the development of Arita Sarayama was actively encouraged by the second and third Nabeshima fief lords, Mitsushige and Tsunashige, who ruled the fief during the Empō (1673–81), Teikyō (1684–88), and Genroku (1688–1704) eras.

Evidence from the *Sarayama Daikan kyūki*, together with the inscriptions on pottery molds and records of the Sakaida family, show that in the late Kakiemon period (1844–68, from the Hoei to Keiō eras), Shibuemon, Sanaemon, Wasuke, and other kinsmen of the Kakiemon family worked together under the village headman and *kama-nushi*, Kakiemon. They manufactured under a semi-mass-production system in response to domestic demand.

Pure Imari and Kakiemon Styles
During the Edo period, the porcelain wares fired at Arita Sarayama kilns in Hizen Province were collectively called Imari ware. The term Imari is mentioned in the *Kakumei-ki* and other literary sources and also in the *Sankai meisen zu-e* ("Illustrated Catalogue of Famous Land and Marine Products"). In Europe they were classified as Japanese porcelain in contrast with Chinese porcelain. A record of the Dutch East India Company includes a word thought to read Fizen (Hizen). It is hard to classify strictly the white porcelain, celadon, cobalt underglaze decorated (*sometsuke*) porcelain, and enameled porcelains made in Arita County, but they are tentatively classifiable into pure Imari and Kakiemon styles. The style of the official kiln run by the Nabeshima fief should be added to these two. The decade between about 1605 and 1619 is called the period of porcelain nascency and stabilization and is characterized by Korean Yi dynasty forms and styles, but around 1640 porcelain was brought to perfection and took on a new style close to that of late Ming dynasty Chinese *sometsuke*. *Aka-e* is generally believed to have been perfected around 1643, and early Arita *aka-e* (early Imari *aka-e*) at its outset went through a stage of imitating Chinese blue-and-white and enameled porcelain—more in a late Ming than a pure Imari style. At their start, therefore, the

workshops at both Arita Uchiyama and at Nangawara-yama produced wares that were similar in design, all copying the colors and designs of the Chinese porcelain being made at the time.

The distinction between pure Imari and Kakiemon styles around 1672 was still unclear. This was when craftsmen specializing in painting enamel decoration were brought together in Arita Sarayama. This was a time in which all Imari wares copied, in a somewhat simplified treatment, the Chinese Ming *fuyo-de* form of decoration (a large central medallion surrounded by panels enclosing decorative motifs) as well as Ming paintings of flowers in baskets, flowering grasses, flowers-and-birds, and other such motifs. Some experts prefer not to make a classification into pure Imari and Kakiemon styles; yet the need to adapt to market demand made it natural for the two distinct styles to emerge, with separate forms, designs, and colors, after 1670 in the Arita Sarayama area. A relatively clear difference between Imari and Kakiemon styles began to appear in the second half of the seventeenth century, when the overseas export market became brisk. The characteristics of the pure Imari style are generally understood to be:

1) Indiscriminate use of a single clay body for jars, bowls, and dishes regardless of whether they were to be decorated with *sometsuke* (underglaze cobalt) or polychrome enamels.

2) In the wide range of pottery produced, wares reveal different levels of quality—each level fairly clearly conforming to different types of demand in Japan—*kenjō* (used for presentation to the imperial court) Imari, export Imari, and Imari wares for everyday use.

3) Extremely complex design in which pots are mostly divided into separate small units, each consisting of combinations of realistic and geometrically composed stylized motifs together with background patterns.

4) The fine and elaborate execution of the decoration on the "front" or interior of dishes and bowls, but very brief, sketchy depictions on the "back" or exterior of pots.

5) Combinations of different motifs, which tend to be flat, stereotyped, and compact, in *hana-zume* ("packed flowers") or *nuri-tsubushi* (allover painting) style, which disregards spacing and almost ends up concealing the white porcelain body. Colors and color combinations also tend to be very florid. An overly decorative expression, somewhat removed

from the sort of aesthetic sense required in works of art, was also characteristic of the pure Imari style

In contrast with the pure Imari style, which made its start with complex, excessive motifs and coloring in the wake of the Chinese Wanli mode, the Kakiemon style exhibits the following:

1) Careful attention paid to all processes of manufacture, from the refinement of clay bodies for both *sometsuke* and *iro-e* to glazing and firing. This point is clear from the contents of the *Tsuchi-awase-chō* ("Notebook on Preparation of Clay Bodies") owned by the Kakiemon family and dated 1690, which prove that the clays for *sometsuke*, cobalt underglaze combined with enamel decoration (*some-nishiki* or *nishiki-e*), and milk-white body (*nigoshi-de*) were prepared with due consideration of the decoration to be applied to the wares. The *Tsuchi chōgō nikae* ("Memoranda of Clay Recipes") transmitted in the Sakaida family contains data on *ondōgu tsuchi* (clay recipes for wares made on special order by the fief government), *ondōgu shiroyaki tsuchi* (clay recipes for milk-white wares for use in the fief government and the lord's castle), as well as on clays for *jōmono* (high-quality pieces), *nami sometsuke* (*sometsuke* of ordinary quality), and *sometsuke*. Private notebooks give a still more detailed listing of clay recipes for celadon, large bowls, *ōmono* ("large pieces," that is, jars), *fuchi-beni* (iron red pigment for coloring the mouth rim), and so on. It appears to be a general trend in the study of Kakiemon style to lay importance solely on the subjects and color effects of the decoration. However, notebooks reveal that workshops of the Kakiemon group made a careful study of all manufacturing processes, beginning with preparation of clay bodies. We should not overlook the fact that the Kakiemon style is also reflected in the preliminary processes of clay preparation and forming.

2) After circular bowls, square bowls, and dishes of the Kakiemon style had been bisque fired, they almost always had the mouth rim painted in iron red (*fuchi-beni,* "mouth-rim red") before glaze firing. The *fuchi-beni* style, however, was rarely introduced into pure Imari wares. It was used as a precaution against chipping, which was liable to occur on the mouth rim of a bowl or dish, and served also to emphasize the composition of the enamel decoration. *Fuchi-beni* is generally thought to be a form of overglazing, but this is not so. It should be understood that it was applied at the same time as the glaze following bisque firing. This technique thus serves

as a clue towards determining whether a piece having *fuchi-beni* is genuine or false.

3) The methods of forming included wheel-throwing for *maru-mono* ("round shapes," dishes, bowls) and *fukuro-mono* ("baggy shapes," jars, vases) and *kata-uchi* (molding), in which the body roughly fashioned by wheel-throwing was finished off while soft in a mold. Dishes around twenty centimeters in diameter were made into shallow, less deeply curving shapes to prevent them from warping. Deep bowls were formed in press molds (*kata-uchi*). Bowls and dishes with relief decorations (water or stream, standing tree, *takara-zukushi* or "treasures" designs, etc.) were also made by press molding. The milk-white *mukozuke* bowls with grape and squirrel design illustrated in Plate 51 are excellent examples of faceted forms (*mentori*) with clear, sharp angles.

4) Shards unearthed on old kiln sites prove that milk-white bodied pieces were fired not only at Kakiemon kilns but also at Arita Uchiyama kilns. Those made at the latter, however, are mostly small bowls and dishes, while those in the Kakiemon style include many larger-sized ones such as jars around twenty-seven centimeters in height, bowls and dishes measuring thirty centimeters in diameter, as well as covered vessels with relief decorations. A similar trend is noted in *densei* examples (extant pieces handed down through the centuries).

5) Subjects and compositions recalling Far Eastern and particularly the Japanese genre of painting are dominant in decoration, both on *sometsuke* and *iro-e* works. Often the same motifs found on *maki-e* lacquer and textiles appear, perhaps derived from the artists' and craftsmen's copybooks published throughout the Edo period.

6) Naturalistic designs representing spring and autumn, especially, show the obvious influence of Japanese painting of the Kanō, Tosa, and Shijō schools in the Edo period. There has also been an indirect incorporation of the Sotatsu and Kōrin styles of painting, which evidences how potters tried to establish an essentially Japanese style of porcelain decoration.

7) One characteristic of the Kakiemon style of porcelain decoration is to be found in the splendid balance between the decorated and negative areas, the composition being conceived, it may be said, as "a work of art on a porcelain clay body." The style characteristically aims at elegant understatement by avoiding excessive decoration and placing emphasis

on ample spacing and leaving much of the milk-white porcelain empty of decoration. Compositions sometimes recall early Edo folding screens, small fan paintings, or *maki-e* lacquer designs of the Muromachi period, all showing compositional characteristics of Japanese painting.

8) A common feature of Kakiemon style decoration on both *sometsuke* and *iro-e* wares is the strength and fluency of brushwork. Typical examples are the large octagonal jar with flower-and-bird design illustrated on the cover and the jar shown in Plate 23. One can see the Japanese idyllic and lyric sense in the dynamic depiction of birds and the flowing strokes of the brush used for leaf veins, flower petals, and flower hearts on these jars, as well as in the penetrating observation of birds in movement and of their fine feathers seen on the dish of Plate 46 and the tile of Plate 35.

9) Unlike that of pure Imari style wares, the artistic quality of the decoration on the "back" side of each pot matches that of the design on the "front." Although such motifs as tendril scrolls, peony scrolls, and so on can be somewhat monotonous in composition, they are executed in flowing brushstrokes.

10) Study of *densei* (handed down, as compared to excavated) pieces of the Kakiemon style suggests that the Kakiemon kiln was a quasiofficial kiln that followed along the lines of the official workshop of the Nabeshima fief in employing potters and painters (decorators) of distinguished ability. It seems that for decoration, especially, artisans good at Japanese style painting were employed.

11) The Kakiemon style features combinations of colors rather than single colors, and the composition is generally accentuated by one or two colors in particular. Thus, on some pieces red and blue, on others blue and green, are the key shades. While the pure Imari style is characterized by bright, deep, loud colors, the Kakiemon style prefers paler hues, but always paying full heed to the color or colors that are to be highlighted. The pigments were also prepared by the painters themselves. The *Aka-e enogu awase oboe* ("Memoranda on Recipes of *Aka-e* Pigments") records recipes for both deep and light enamel shades and even includes mention of special enamels used for certain parts of a composition.

In general, one can say that the Kakiemon style maintains a beauty featuring a highly refined artistic quality and noble grace.

Wares from the kilns officially run by the Nabeshima fief were a monopoly of the fief government. These pots featured a dignified, sonorous beauty, which may have suited the taste of daimyo but tended to be overly devoted to technical precision, their decoration being even more decorative than any painting and being done in a somewhat stiff style of brushwork. Furthermore, while the Kakiemon and pure Imari styles used many enamel colors, enameled Nabeshima wares made at the official kilns were mainly in the three colors of red, green, and yellow. The fact that three different styles—Imari, Kakiemon, and Nabeshima—existed within the same realm of Hizen enameled porcelain meant that the range of taste and demand of the times could be satisfied.

To avoid misunderstanding, however, it should be stressed that due to the increase in foreign trade in and after the middle Edo period, both the Kakiemon and pure Imari styles (the latter including some Chinese stylistic traits) began to incorporate certain elements from each other in order to increase their sales potential. This makes it difficult to distinguish clearly between the two styles; many pieces need reconsideration with regard to their classification.

Classification of Kakiemon Style Wares
Pots handed down over the centuries (*densei* pieces) that have been categorized somewhat broadly as being in the Kakiemon style may be seen as having been fired in the following kilns.

1) Mainstream Kakiemon wares—porcelain wares fired at kilns under the direct management of the Sakaida *kama-nushi*, Kakiemon, with the help of other members of the Sakaida family.

2) Collateral Kakiemon wares—pots fired at the porcelain kilns at Kami (Upper) and Shimo (Lower) Nangawara-yama (for example, the Higuchi, Genzaemon, and Mukurodani kilns) or those made at *yoriai-gama* (cooperative kilns) with common subject matter and design composition. These "collateral" Kakiemon wares consist mostly of cobalt underglaze decorated porcelains (*sometsuke*).

3) Next to be noted are the exclusively *sometsuke* wares fired in the kilns of the Matsugatane-gama group and known as the official wares of the Ogi clan. These were made when members of the Sakaida family participated in the kilns.

In distinguishing different types of porcelain, it should be remembered that *sometsuke* pieces likely to be classified as in the Kakiemon style in fact include

many pots from the Higuchi and Mukurodani kilns at Kami-Nangawara-yama. Compared with mainstream Kakiemon wares, however, the clay body of these pots is coarser. The cobalt pigment used on them contains impurities and fires a darker, duller blue than the pure cobalt, and the decoration is rough and crude.

The Beauty of the Kakiemon Style

There are no distinct designs characteristic of wares generally classified as Kakiemon style during the period when enameled overglazing was established. But one can see a general trend towards small vessels with designs of flowering grasses or peonies and bowls with cloud-and-dragon, phoenix, or chrysanthemum motifs drawn with economic use of the brush in a style apparently inspired by Chinese underglaze cobalt and enamel decorated wares *(gosu aka-e)*. There may also have been some influence from Chinese Wanli and Tianji (T'ien-chi; 1621–27) enamel decoration styles. At the moment it is believed that a characteristically Japanese style began to appear once the porcelain body had become more or less fixed and the techniques of enamel painting and firing perfected.

Kakiemon style designs may be roughly classified into three types: realistic renderings, relatively conventionalized forms, and abstract patterns. In addition to copying Ming *sometsuke* and *iro-e* porcelain, another notable feature is the recurrence of subjects, themes, motifs, and compositions borrowed from Japanese painting (much of which is ultimately of Chinese inspiration). There are also designs emulating textile patterns of the East, including those of India and Java. Some motifs were partly influenced by European designs.

1) Work influenced by Chinese polychrome enamel-decorated designs frequent in the late Ming and early Qing periods (especially of the Kangxi [K'ang-hsi] reign [1662–1722]). These display two or more separate panels or units separated by background patterns, the major decorated panels enclosing Chinese-style pictures of flower-and-bird, landscape, figure, plant, and other motifs. The jar *(jinkō tsubo)* with flower-and-bird design registered as a Japanese Important Cultural Property is a typical example.

2) Designs influenced by Japanese painting of the Edo period are typified by the many dishes and bowls with designs of flowering plants or of flower-and-bird subjects with themes of spring and autumn.

These show various degrees of influence of the early Edo period painting of the Kanō and Tosa schools. (Cf. Plates 11, 12, 15, 19, 22, 23, 46, 47, etc.)

3) Designs for *odōgu* wares. Products of the Kakiemon kiln, like those of the Nabeshima official kiln, include many that were made as *odōgu* (objects for use by daimyo) by order of the fief government and of other feudal lords. The file of *Gochūmon egata* ("Designs Supplied to Order") preserved in the Sakaida family records the names of orderers, ordered items, quantity, time limit of delivery, prices, and specimen designs *(egata)*, giving examples of forms and decorations.

4) Designs taken from woodblock printed picture copybooks. Many woodblock printed books of exemplary designs were published in Naniwa (Osaka) and Edo (Tokyo) in the Edo period, among them the *Ehon tsūhō shi, Ehon seisho-chō, Oshi-e tekagami, Ehon keiko-chō, Ehon noyama gusa,* etc. *Densei* wares show that pictures in these books were frequently borrowed for *sometsuke* and *iro-e* designs.

5) Designs of the undersides of vessels. The undersides of Kakiemon vessels are commonly decorated with simple tendril scrolls or peony scrolls, mostly in cobalt underglaze blue only. The design of the *shippō* (interlocking circle) pattern illustrated in the above-mentioned *Gochūmon egata* ("Designs Supplied to Order") was the basic type of undersurface design on Nabeshima official wares and can also be found on Kakiemon wares. A foot decorated on the exterior with the conventional comb pattern that was discovered among porcelain shards unearthed during recent excavation of an old Kakiemon kiln site at Nangawara-yama will help in the classification of Kakiemon designs.

6) Influence of foreign designs. In answer to seventeenth-century European taste for chinoiserie, Hizen porcelain began to be exported in quantity by the Dutch East India Company. Symmetric designs of flowering plant motifs appeared in the Kakiemon style, and these were often called Dutch designs. However, it appears that such flowering plant designs were more frequently borrowed from patterns of Indian printed textiles. Very few porcelain wares made for export were decorated with European figure subjects; rather, such designs were made in response to domestic, not overseas, demand.

7) Unique composite designs. One particularly noteworthy stylistic trait in Kakiemon ware is the unique construction of composite designs. In contrast

with the complicated, incongruous compositions of the pure Imari style, Kakiemon style design compositions are not simply a number of mutually independent elements haphazardly put together but consist of harmonious combinations of a few single units. The resulting composition thus forms a coherent and well-controlled whole unlike that of the pure Imari style.

Take, for example, the typical millet and quail, bamboo and tiger, and other such composite designs in the Kakiemon style. The main motif is placed either to the right or left of the center and the subordinate motif diagonally across from it to give the total design balance. Alternatively, a flower-and-bird design is painted as the main motif on the "front" side of a jar, and a design of flowering autumn plants in light touches on the "back" side plays a subordinate role. Other examples of such composite designs are:

Flowering plant motifs: rock and plum tree; rock and chrysanthemum; rock and autumn grasses; brushwood fence and ivy.

Flower-and-bird motifs: plum tree and spring birds; peony and phoenix; paulownia and phoenix; chrysanthemum and wild bird.

Traditional groupings: shō-chiku-bai (pine, bamboo and plum, the three "lucky" plants); peony and Chinese lion (the "queen" of flowers and "king" of beasts); bamboo and tiger; quail and flowering grasses; maple and deer; waves and plovers; karako (Chinese boys) and autumn grasses; Chinese figure and flowering grasses; flowering grasses and butterflies.

Designs combining these motifs are painted in deftly balanced compositions on the surfaces of jars, bowls, dishes, square bowls and vessels of various shapes. The distinguished talents of the decorators created first-class "porcelain paintings" rather than more ornamental designs.

Tendency towards Stylization in Kakiemon Designs
I am not the only man who, when appreciating works of Kakiemon style (mainstream and collateral Kakiemon) housed and exhibited in Japanese and foreign art museums and collections, feels a nuance different from pure Imari style, as stated above.

The Kakiemon style rests to some extent upon the academy painting styles of the Far East, notably those of the Song dynasty in China and such purely Japanese genres as the classical *Yamato-e*.

Quail designs, which have become one of the fixed types of decoration in the Kakiemon style, find their ultimate source in masterpieces on this subject by Li Anchong (Li An-chung), who belonged to the Song Imperial Painting Academy. In Japan, quails were frequently depicted by the artist Tosa Mitsuoki on folding screens at the beginning of the seventeenth century. This style and subject matter is reproduced in the section on "September Subjects for Poem-Pictures of the Twelve Months: Quails and Rushes" of the *Ehon tsūhō shi* mentioned above. The *Oshi-e tekagami*, published in 1636 in Naniwa (Osaka), also contains a sketch entitled "Autumn, Quails" by Ōoka Michinobu. Needless to say, the Kakiemon kiln and its collateral kilns at Nangawara borrowed motifs and compositions from these sources in answer to the taste of the time. Maple and deer designs, like those seen in Plates 42 and 44 are also familiar, typically Japanese motifs. A lacquer ware writing box from the Muromachi period is decorated on the inside of its cover with deer and autumn plants, probably inspired by an autumn poem from the *Kokinshū* poetry anthology that goes: "In a rustic place, how forlorn the autumn when the cry of deer awaken us." In Volume 3 of the *Ehon tsūhō shi* can be found a picture of the "Eight Sights in the Southern Capital [Nara]: Deer in the Field of Kasuga," and this is another fixed design of the Kakiemon style. Shards with maple and deer designs in *sometsuke* may still be discovered occasionally in the old kiln sites on the hill behind the present Kakiemon kiln. The designs are richly lyrical and reminiscent of the old poem: "The autumn wind must be chill on Kasuga Mountain; deer cry sadly in the fields at its foot."

One undercurrent of the Kakiemon style always present—sometimes explicitly, at other times implicitly—is the influence of the colorful *Yamato-e* genre of painting. In this polychrome porcelain decoration there is a richly lyrical naturalism that expresses the very heart of the Japanese. The lingering resonance of the understated, amply spaced designs, preserving as much of the pure white porcelain surface as possible, and the fresh color combinations constitute a uniquely Japanese realm. The tradition of the Kakiemon style arose from and is an expression of the mind and aesthetic sense of the Japanese.

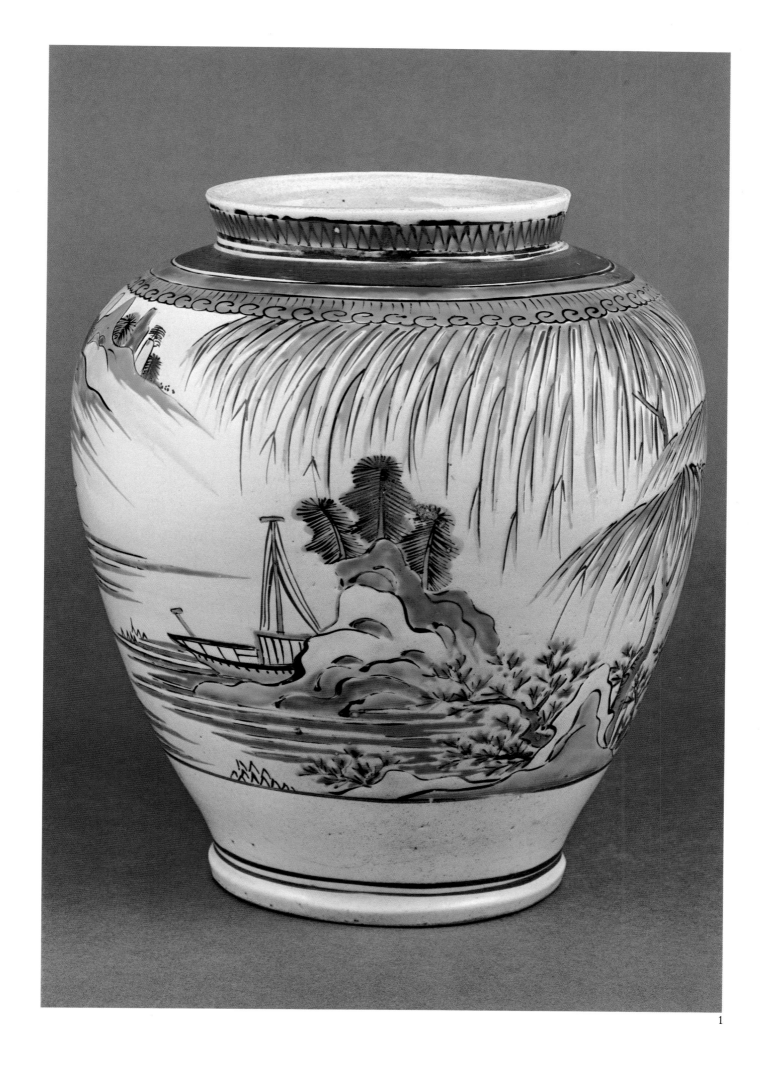

1. *Jar, landscape design. H. 26.0 cm. Idemitsu Museum of Art.*

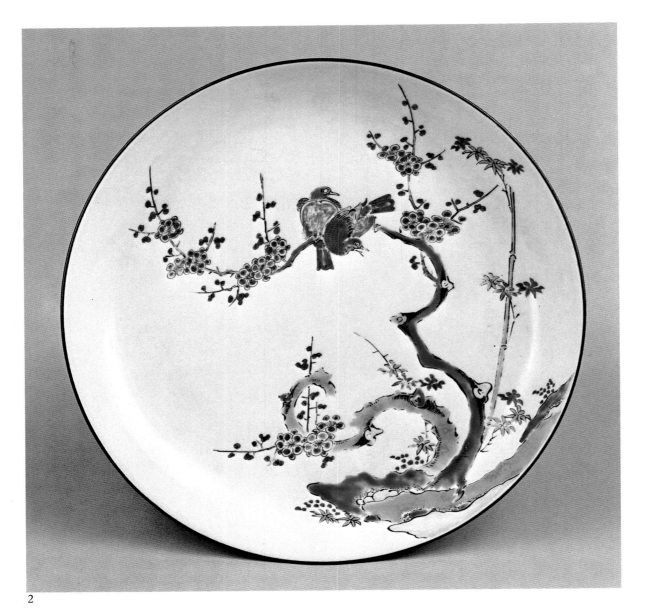

2

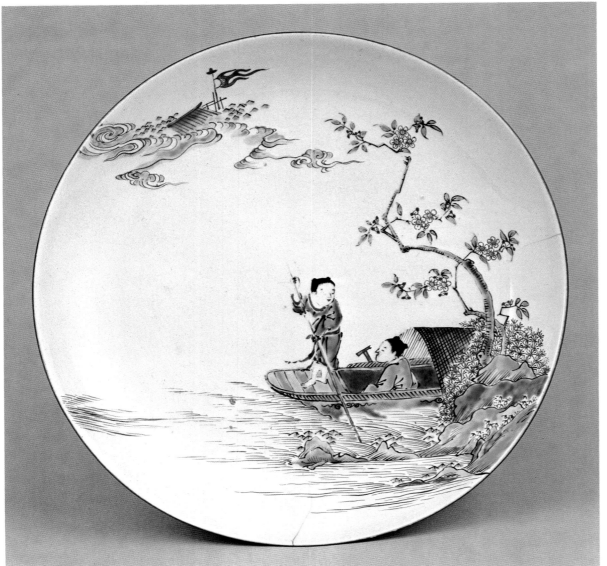

2. *Dish, bamboo, plum, and bird design. D. 24.8 cm. Early Edo period.*

3. *Dish, boating design. D. 23.1 cm. Early to Middle Edo period. Tanakamaru Collection.*

3

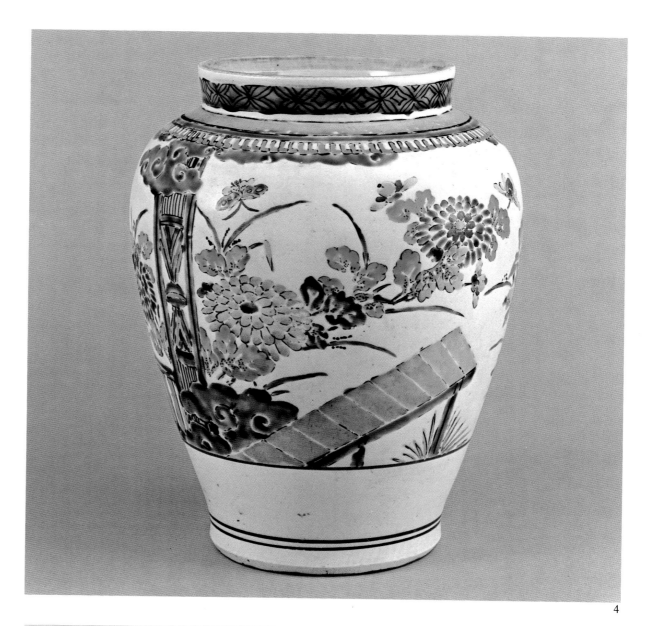

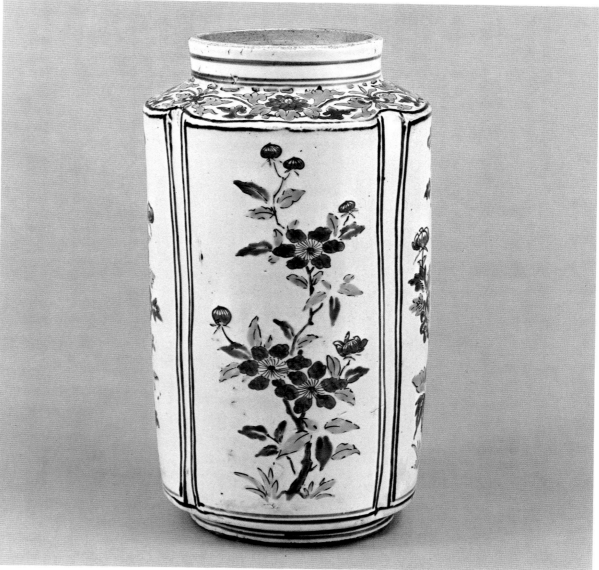

4. *Jar, flower and butterfly design in three panels. H. 22.2 cm. Early Edo period. Saga Prefectural Museum.*

5. *Jar, flowering grasses in four panels. H. 25.5 cm. Kakiemon Collection.*

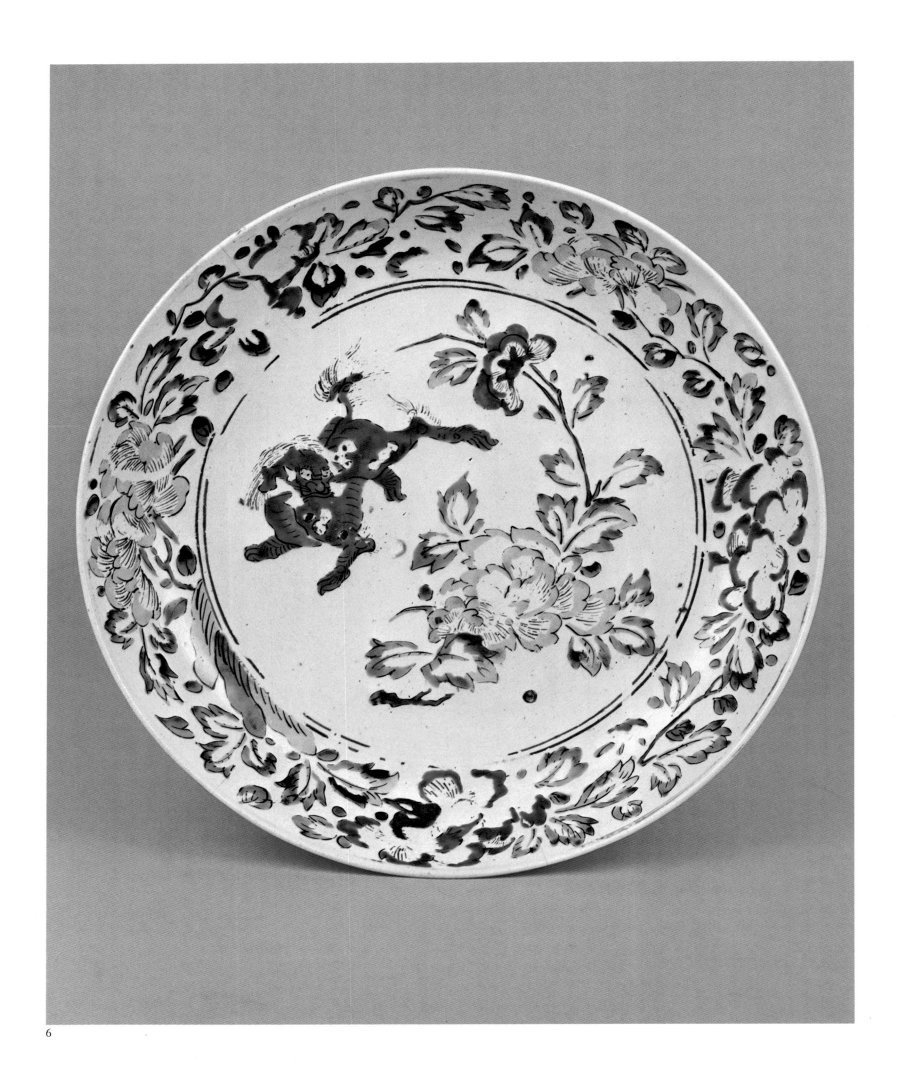

6

6. *Dish, Chinese lion and peony design. D. 27.3 cm. Early Edo period. Gamachi Collection.*

16

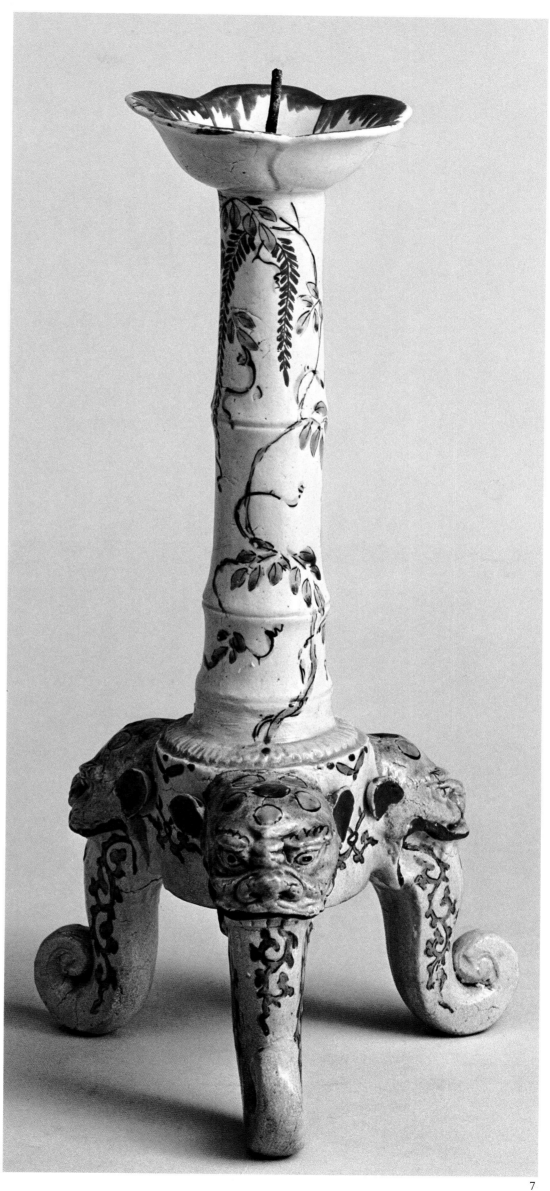

7. *Three-legged candlestick, wisteria design. H. 33.0*
Middle Edo period. Tanakamaru Collection.

7

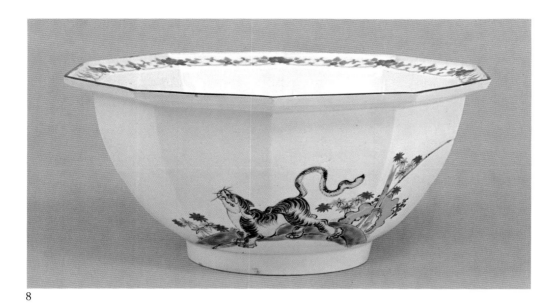

8

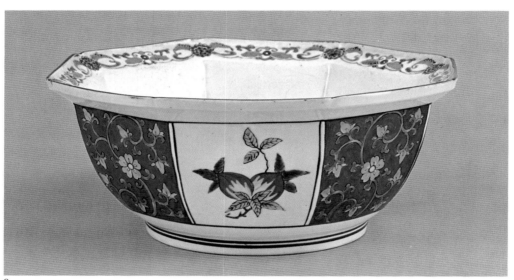

9

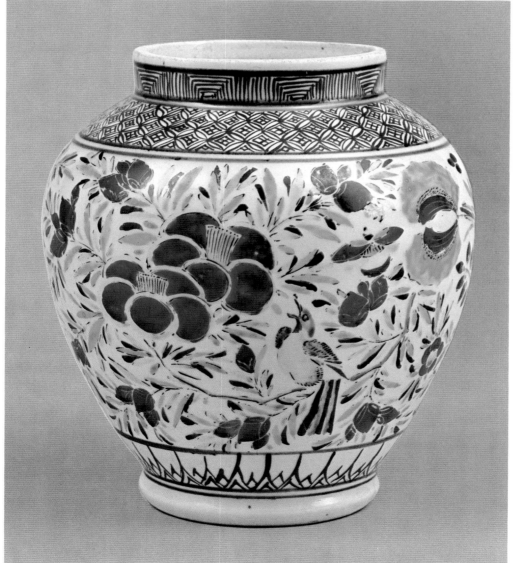

8. *Ten-sided bowl, bamboo and tiger design. D. 23.0 cm. Middle Edo period. Tanakamaru Collection.*

9. *Octagonal bowl, peach and floral scroll design. D. 21.3 cm. Middle Edo period. Tanakamaru Collection.*

10. *Jar, flower-and-bird design. H. 16.0 cm. Middle Edo period.*

10

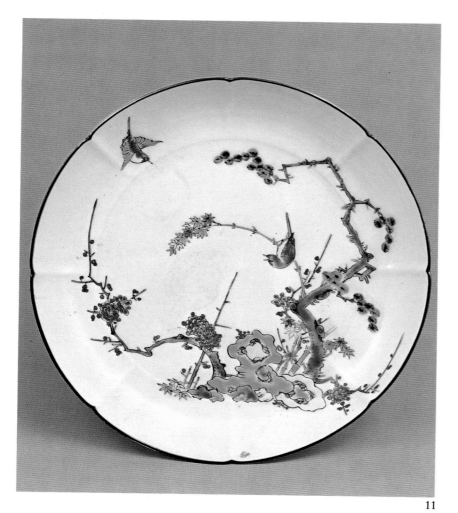

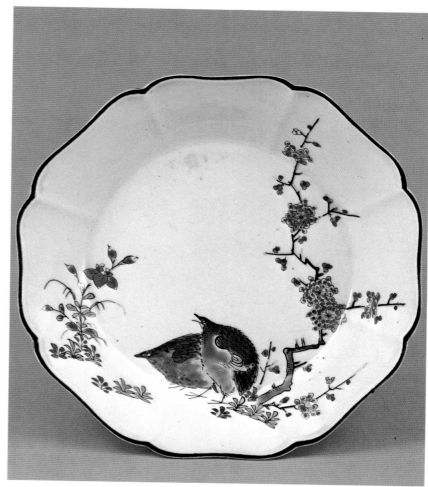

11

12

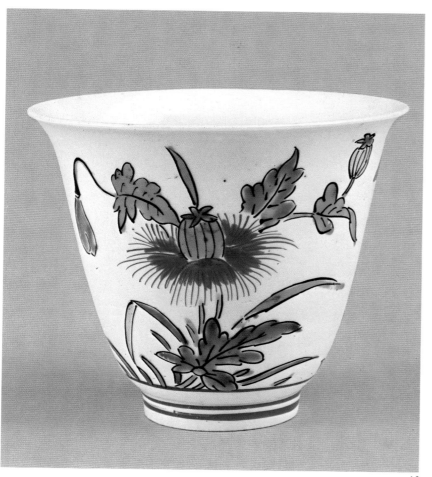

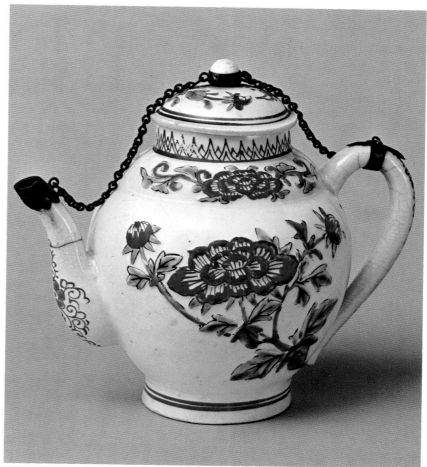

13

14

EUROPEAN TASTE (11—23)

11. *Dish, pine–bamboo–plum and bird design. D. 21.8 cm. Kakiemon Collection.*

12. *Dish, plum and quail design. D. 13.2 cm. Saga Prefectural Museum.*

13. *Small deep bowl, poppy design. D. 9.8 cm.*

14. *Ewer, peony design. H. 15.3 cm.*

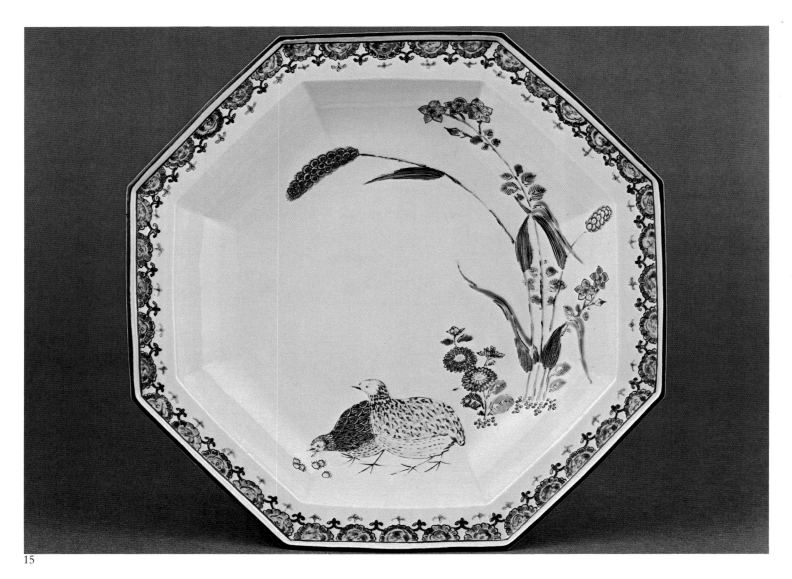

15

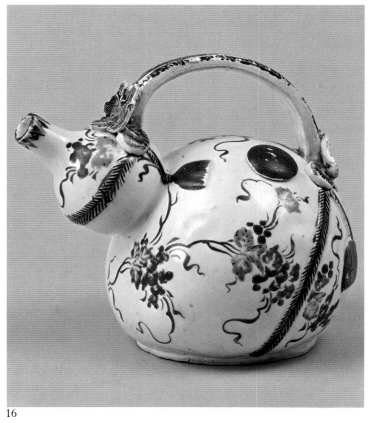

16

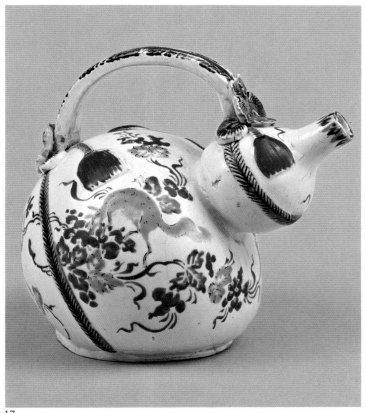

17

15. *Octagonal bowl, millet and quail design and border band of halved floral roundels. D. 22.3 cm. Idemitsu Museum of Art.*

16, 17. *Gourd-shaped ewer, grape and squirrel design. H. 16.3 cm.*

20

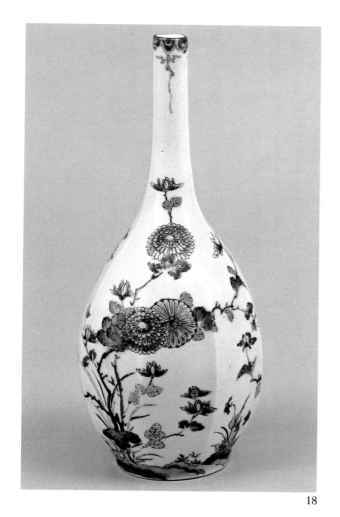

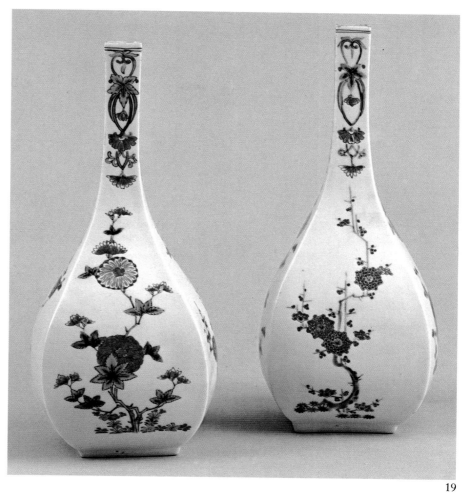

18

19

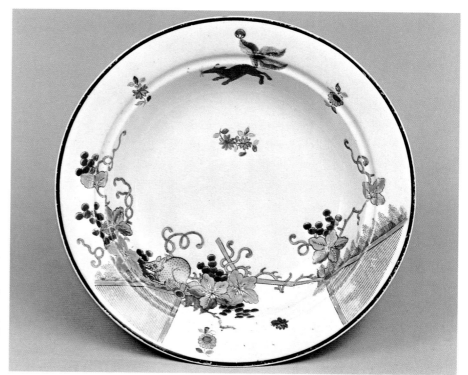

20

18. *Narrow-necked hexagonal bottle, rock and chrysanthemum design. H. 23.3 cm. Saga Prefectural Museum*

19. *Narrow-necked square bottles, plum and chrysanthemum designs. Left: H. 21.5 cm. Kakiemon Collection.*

20. *European copies of Kakiemon style polychrome overglaze enameled wares. H. 1.8–11.8 cm. D. 5.1–22.5 cm. Saga Prefectural Museum.*

21. *Dish, grape and squirrel design. Meissen porcelain. D. 20.5 cm.*

21

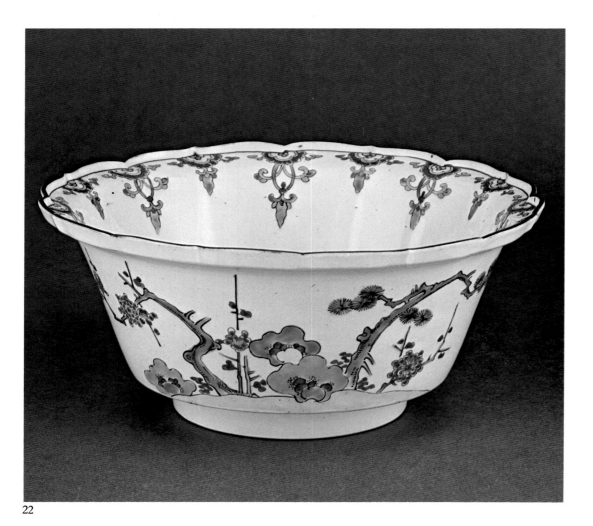

22

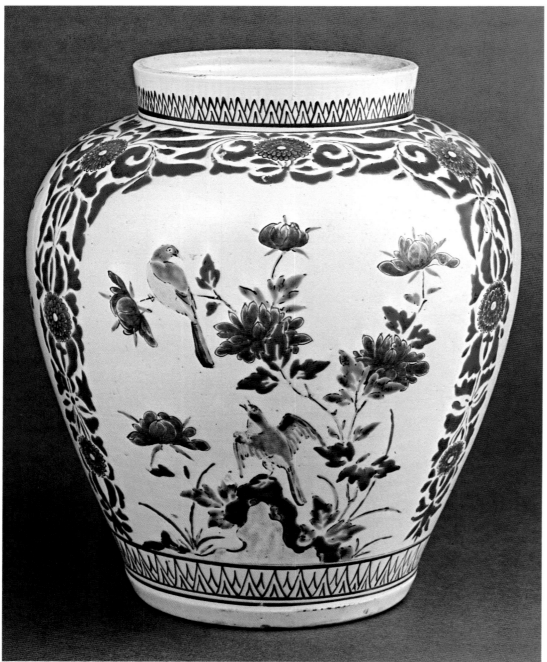

22. Foliate bowl, pine-bamboo-plum design and border band with floral pattern. D. 17.1 cm. Idemitsu Museum of Art.

23. Jar, flower-and-bird designs in three panels. H. 25.9 cm. Idemitsu Museum of Art.

23

24

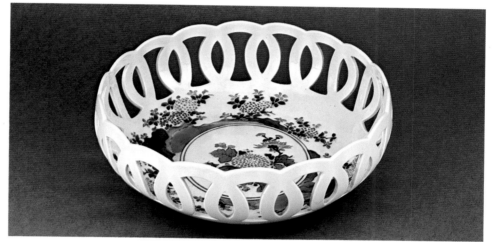

25

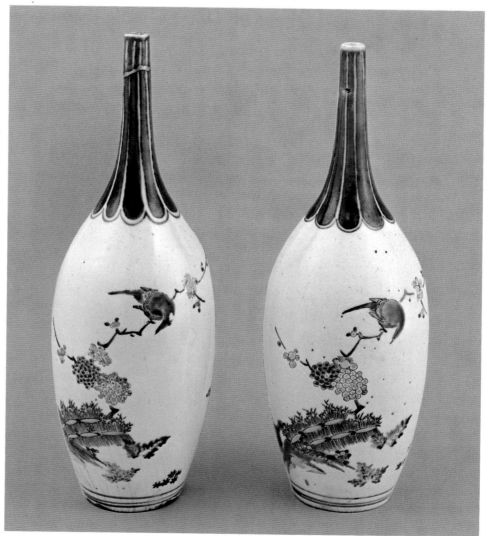

24. *Lobed dish, rock and autumn grasses design. 21.2 × 18.4 cm. Middle Edo period. Tanakamaru Collection.*

25. *Bowl, chrysanthemum and peony design, openwork border of linked circles. D. 25.8 cm. Idemitsu Museum of Art.*

26. *Pair of small-necked bottles, brushwood fence, flower, and bird designs. Left: H. 25.0 cm.*

26

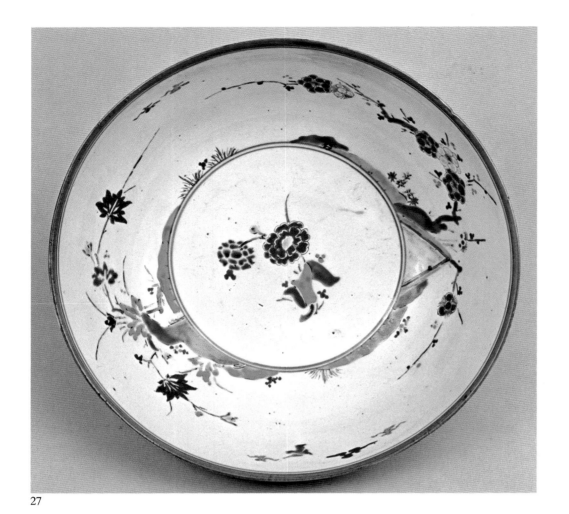

27

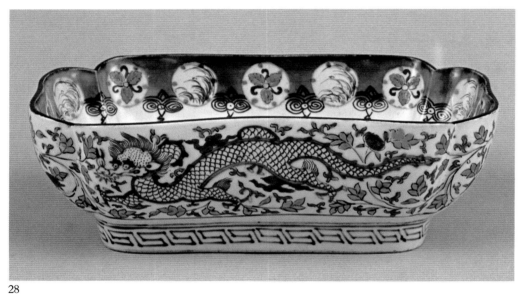

28

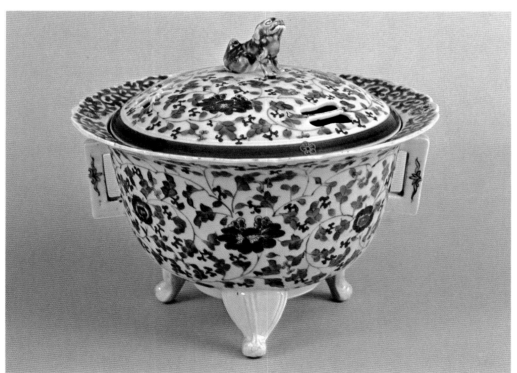

29

27. *Bowl, plum and flowering grass design. D. 26.0 cm.*

28. *Rectangular bowl, dragon and phoenix design. H. 5.0 cm.*

29. *Incense burner, floral scroll design. H. 15.0 cm.*

24

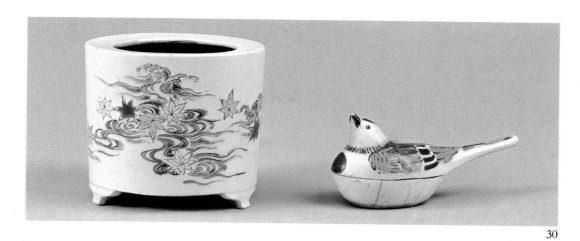

<div align="right">30</div>

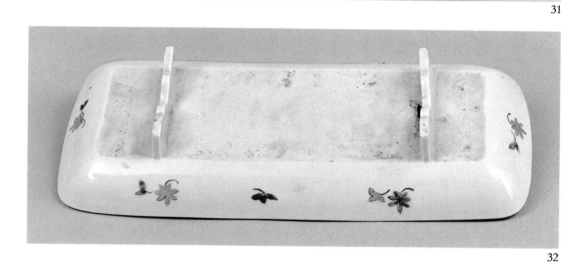

<div align="right">31</div>

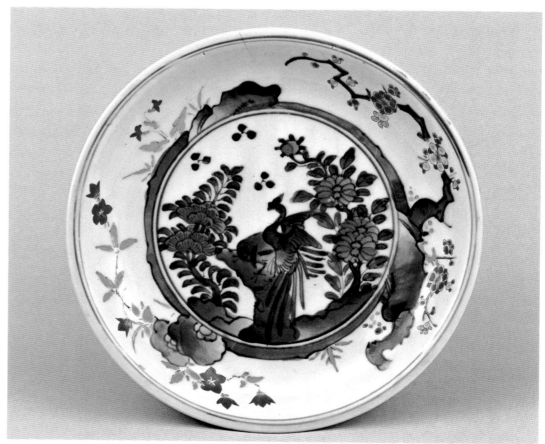

<div align="right">32</div>

30. *Incense burner, maple leaf and stream design; wagtail-shaped incense box. Left: H. 6.4 cm. Middle Edo period.*

31, 32. *Footed rectangular dish, pine-bamboo-plum design. 21.8 × 9.5 cm.*

33. *Dish, flower-and-bird design. D. 18.5 cm. Gamachi Collection.*

<div align="right">33</div>

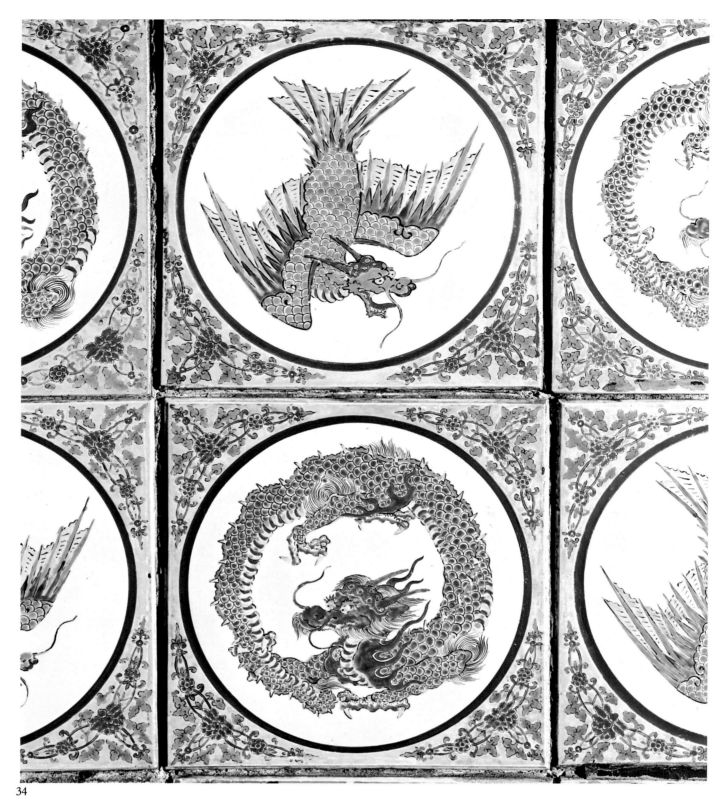

34

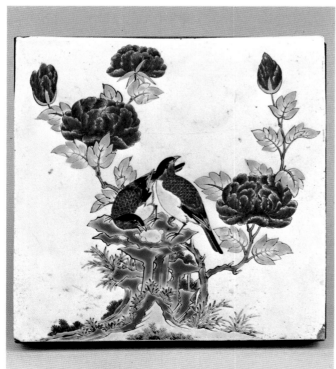

35

34. *Wall tiles, Repository, Nishi-Hongan-ji Temple. Each tile 24.7 cm.
square. Early Edo period.*

35. *Tile, rock and bird design. 18.0 × 17.7 cm. Tanakamaru Collection.*

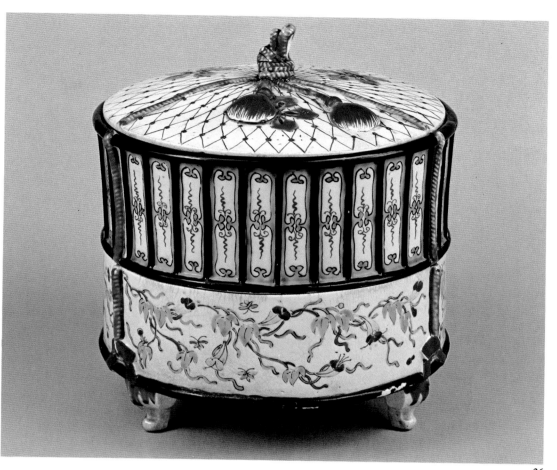

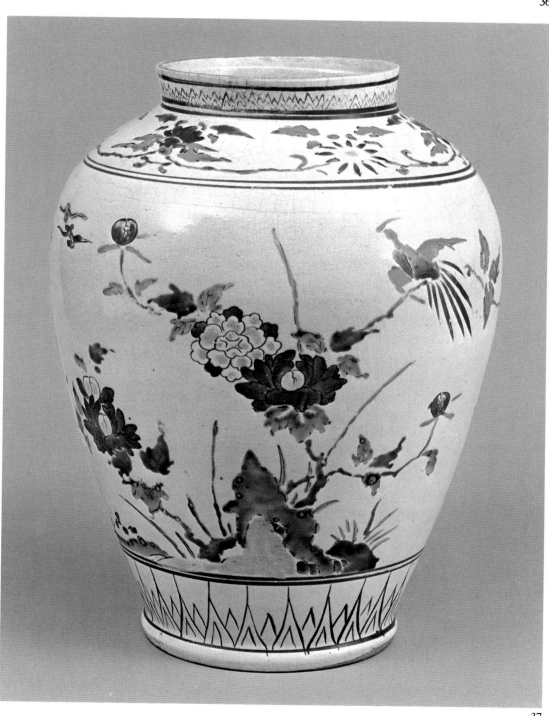

36. *Two-tiered lidded box in the shape of an insect cage, flowing plant design. H. 19.5 cm.*

37. *Jar, flower-and-bird design. H. 28.7 cm.*

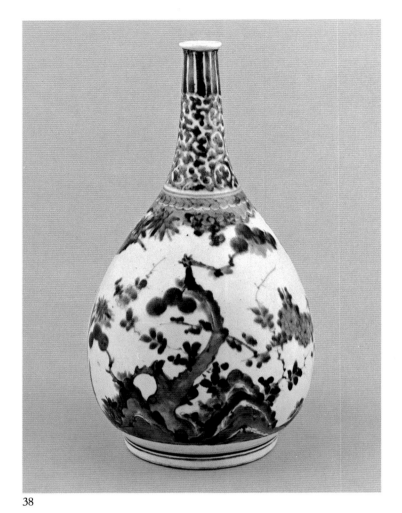

38

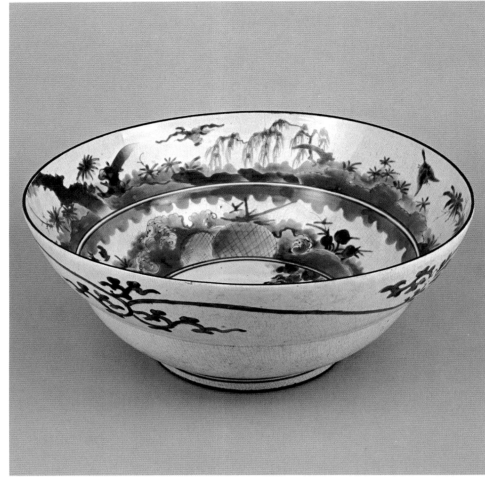

39

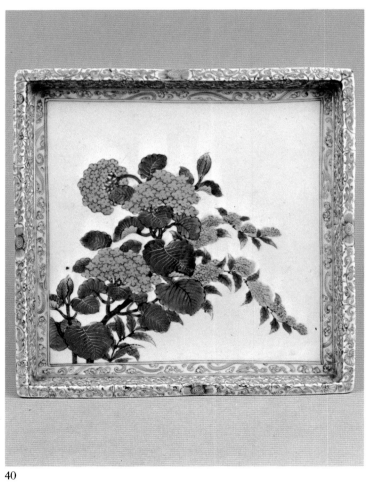

40

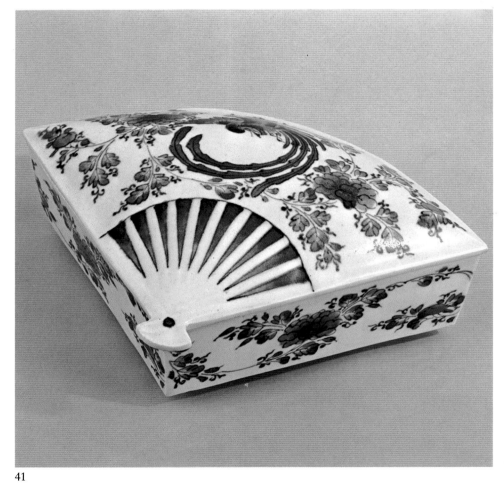

41

Cobalt Underglaze Decorated Porcelain

38. Sometsuke *vase, flower-and-bird and scroll design.*
H. 28.5 cm. Saga Prefectural Museum.

39. *Large* sometsuke *bowl, rock and heron design. H. 16.7
cm., D. 42.0 cm. Tanakamaru Collection.*

40. *Square* sometsuke *dish, hydrangea design. Side 22.7 cm.
Tanakamaru Collection.*

41. Sometsuke *fan-shaped lidded container, peony scroll and
phoenix design. 23.2 × 15.9 × 6.0 cm. Kakiemon Collection.*

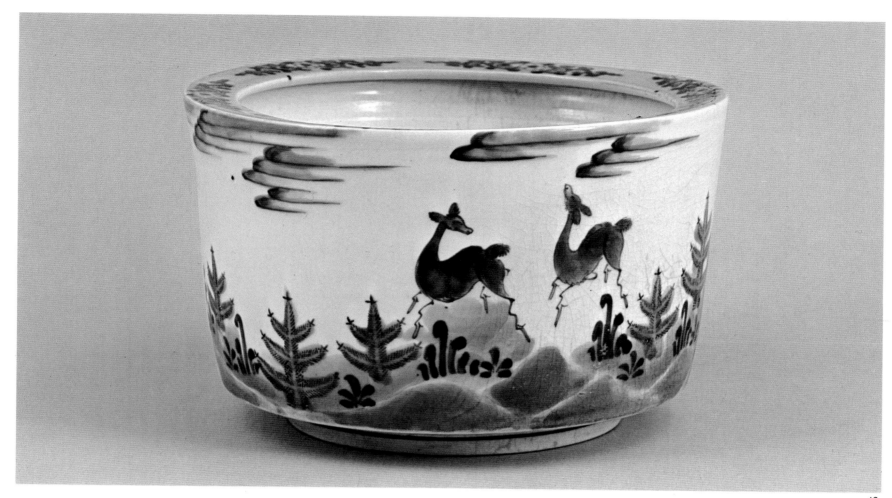

42

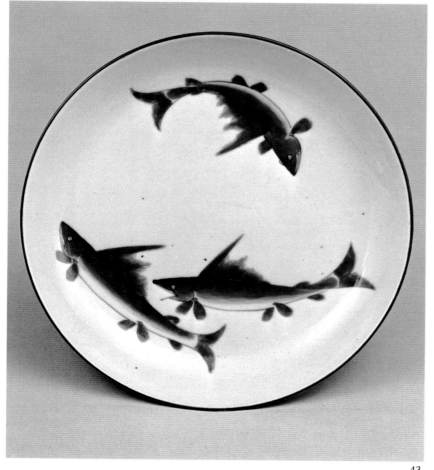

43

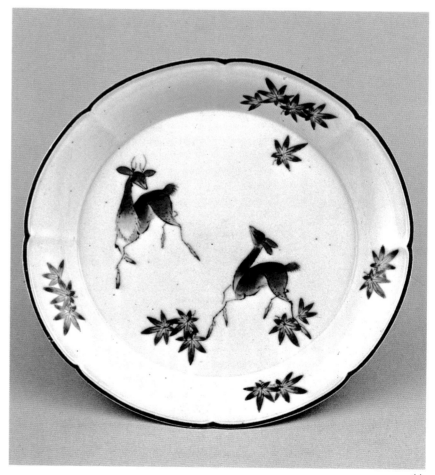

44

42. Sometsuke *incense burner, deer and tree design. H. 12.2 cm. D. 20.0 cm.*

43. Sometsuke *dish, ayu (sweetfish) design. D. 19.3 cm. Tanakamaru Collection.*

44. Sometsuke *dish, maple and deer design. D. 18.0 cm. Gamachi Collection.*

45

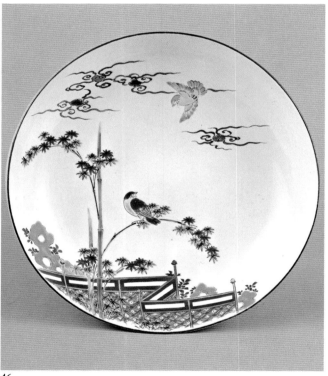

46

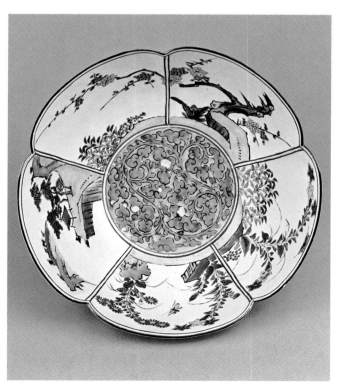

47

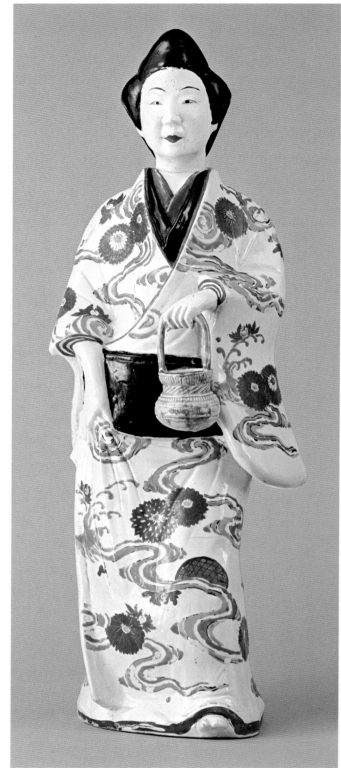

48

45. *Dish, Hotei and autumn grass design. D. 24.8 cm. Tanakamaru Collection.*

46. *Dish, sparrow and bamboo design. D. 21.4 cm. Gamachi Collection.*

47. *Foliate bowl, flower and butterfly design. D. 25.0 cm. Saga Prefectural Museum.*

48. *Figurine of standing woman. H. 57.3 cm.*

49. *Figurine of standing woman. H. 35.5 cm.*

50. *Figurine of standing woman. H. 22.4 cm. Idemitsu Museum of Art.*

51. *Octagonal mukōzuke dishes, grape and squirrel design. Left: 7.5 cm. Tanakamaru Collection.*

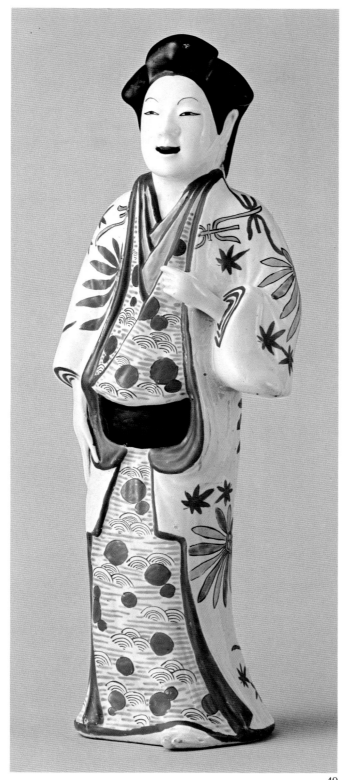

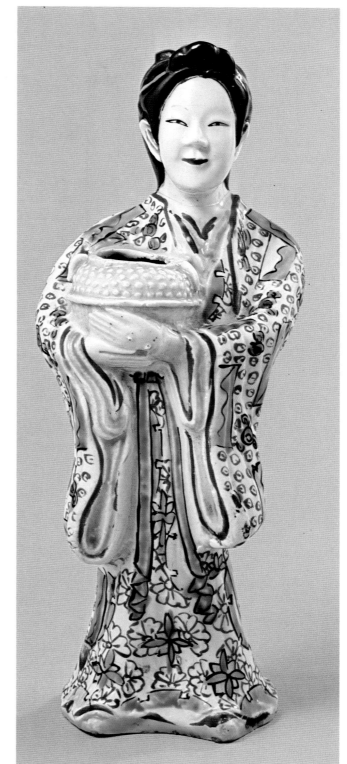

49

50

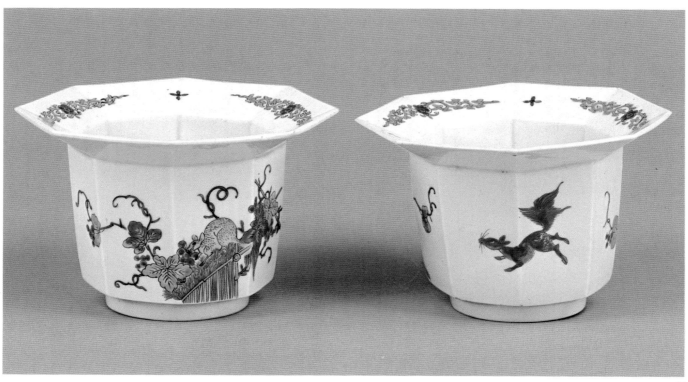

51

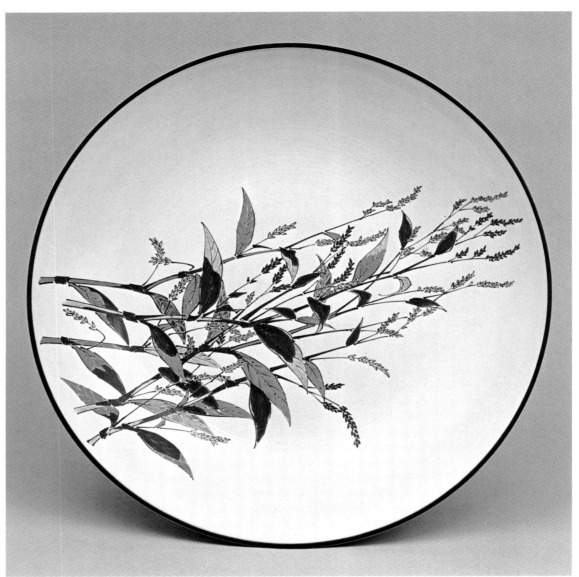

52

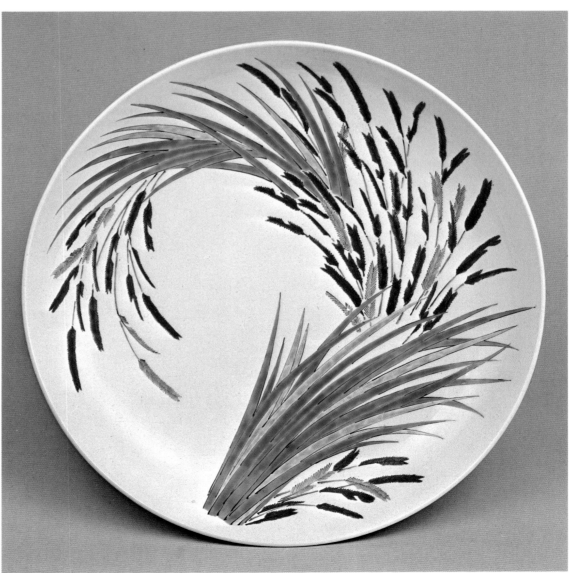

52. *Dish, flowering grass design, by Kakiemon XIII. D. 45.6 cm.*

53. *Large dish, flowering grass design, by Sakaida Masashi. D. 40.3 cm.*

53

Plate Notes

1. *Jar, landscape design. H. 26.0 cm. Middle Edo period. Idemitsu Museum of Art.*

Hizen polychrome enameled jars are generally decorated with natural scenes divided into four, six, and occasionally eight equally distributed sections (known as *warimon*). This jar, however, has been designed with a continuous composition extending horizontally, rather like those found on *fusuma* sliding doors. It is painted on a warm milk-white porcelain body in deep-toned colors and with light, fluent touches. The colors are particularly clear as a result of the good firing. I have seen a similarly decorated jar in the Leeuwarden Museum in the Netherlands. Its Chinese-style landscape design with a moored boat reminded me of an Old Kutani bowl. However, Kakiemon wares feature fine drawing, realistic representation, and bright hues of blue, red, and other colors, while Old Kutani designs are characterized by darker colors, the omission of drawing, and lack of subtle depiction. Both have their respective interesting points, but the Kakiemon style tends to reveal a more florid color scheme.

2. *Dish, bamboo, plum, and bird design. D. 24.8 cm. Early Edo period.*

A dish identical in design and form to the one photographed here may be found in the gallery of Asiatic art in the Rijksmuseum, Amsterdam. A few others were brought back to Japan recently; of these I was able to make positive identification of two as examples of Kakiemon work. They all have a splendid milk-white porcelain body and have flower-and-bird designs in the Kakiemon style. These depict dynamically drawn spring and autumn birds with negative space nicely balancing the design composition. The dish photographed here features particularly bright color tones.

3. *Dish, boating design. D. 23.1 cm. Early to Middle Edo period. Tanakamaru Collection.*

Kakiemon ware designs that feature human figures are mostly Chinese in style, very similar to those illustrated in the *Ehon tsūhō shi*, a pictorial copybook published during the middle Edo period. A few years ago, I studied an example of a dish with an almost identical design, housed in the Porcelain Gallery of the National Museum of Dresden. The dish was in excellent condition, and its milk-white body and polychrome decoration were magnificent. The design on this dish is that of an idyllic landscape reminiscent of a springtime lakeside scene in China. The design is well composed within the circle of the dish's rim and pleasantly evokes the graceful atmosphere of boating. The red and deep blue are especially vivid.

4. *Jar, flower and butterfly design in three panels. H. 22.2 cm. Early Edo period. Saga Prefectural Museum.*

This polychrome enameled jar is an important example, so far as research is concerned, of wares produced during the period in which the Chinese cobalt and enamel decorated style of the Ming dynasty was being adapted to Japanese taste. A jar with similar coloring can be found in the Oriental Antiquities Hall of the British Museum, London. It, too, features deep blue, green, and brownish yellow as the basic colors with a slight touch of red for the hearts of the flowers. The decoration reminds one of folding screen painting of the early Edo period and would seem to be inspired by the Sōtatsu style of decorative painting transposed into a three-paneled ceramic design. The neck, with deep blue washed over a series of concentric circles, is somewhat similar in style to that found on Old Kutani wares.

5. *Jar, flowering grasses in four panels. H. 25.5 cm. Kakiemon Collection.*

This cylindrical jar is lidded and has four painted columns that divide the body of the pot into four sections to constitute panels. These panels are framed with double rectangles drawn freehand, and these enclose, alternately, wild roses with small blossoms and peonies in full bloom. The decoration is simple and matches the vertical shape of the jar, but shows a flowering effect with its forceful brushstrokes.

The painting reveals the hand of a skilled decorator, but the porcelain body contains tiny particles of iron, which remain in the glaze layer. The angular shoulder is painted with floral scrolls in "packed flower" (*hanazume*) style.

6. *Dish, Chinese lion and peony design. D. 27.3 cm. Early Edo period. Gamachi Collection.*

One important task of future research is to classify early examples of Hizen polychrome enameled wares that have come down to us in Japanese and foreign collections, and thereby cast light on the color effects of wares made around 1650, at the time when Japanese enameled porcelain was

brought to perfection. This dish with its Chinese lion and peony design, done in the Chinese style, is valuable for the study of early Hizen as well as early Kakiemon.

It is probably reasonable to suppose, therefore, that the Kakiemon style is that of the early Edo period, and that this early Kakiemon style is typfied by this dish in whose porcelain clay body fine iron particles still remain, and on which the brushwork of the overglaze enamel decoration is yet somewhat rough.

The style is reminiscent of Old Kutani ware (*Ko Kutani*), yet the color tones of the deep blue Chinese lion and the brownish yellow peony flower are Kakiemon in style.

7. *Three-legged candlestick, wisteria design. H. 33.0 cm. Middle Edo period. Tanakamaru Collection.*
The Sakaida Kakiemon family has kept intact all memoranda of orders received from the office of the Nabeshima daimyo as well as from pottery dealers in Naniwa (Osaka) and Kyoto. These documents date from the middle to the late Edo period and include detailed records of what pieces were ordered for what purpose. This candlestick was discovered in the grave of Kuroda Tsunamasa, the fourteenth-generation lord of the Hakata fief (present-day Fukuoka Prefecture), when the tombs of the Kuroda family were moved in 1947 because of construction work necessitated by city planning. Resting on three legs, surmounted by lion masks, and decorated with a wisteria design associated with the Kuroda family crest, this candlestick was without doubt part of the household furnishings of the feudal lord's family. It reveals subtle and careful workmanship done in minute detail. The glaze is partly crazed due to its being buried underground for some time. Interestingly enough, a similarly shaped pair of splendid candlesticks, decorated on their stems with bamboo and plum designs, are to be found in the Victoria and Albert Museum in London. However, the candlesticks there have metal, rather than porcelain cups in which to place the candles.

8. *Ten-sided bowl, bamboo and tiger design. D. 23.0 cm. Middle Edo period. Tanakamaru Collection.*
In the Genroku era (1688–1704) and afterwards during the middle Edo period, the Kakiemon workshop joined other potteries in the Nangawara-yama region to fire their porcelain together. With increasing demand, both at home and abroad, potters began to make identical molded bisque wares. These were then glazed and fired in the cooperative kiln before being decorated with different designs by each workshop. The practice resulted in the frequent production of bowls of hexagonal, and other angular forms. Unlike Imari angular bowls, they show clear, regular forms with sharp ridges. The lip of each pot was usually decorated with a floral design before iron oxide was painted on the rim and the inside of the pot painted with a single flowering spray—usually peonies.

The outside of such a pot is normally decorated in over-

glaze enamel designs with such varied motifs as bamboo and tiger; Chinese figures; landscapes; pine, bamboo, and plum (the three "lucky" plants); flower-and-bird patterns, and so on. These were painted with ample space around them and hence display the beautiful milk-white color of the porcelain body.

9. *Octagonal bowl, peach and floral scroll design. D. 21.3 cm. Middle Edo period. Tanakamaru Collection.*
The faceted bowls illustrated in Plates 8 and 9 were both press molded. Press molding is one characteristic of the Kakiemon style. The bowl seen in Plate 9 is not so high; though angular in form, its inner surface consists of softly curving faces. The bowl's eight sides are decorated alternately with realistic pomegranate sprays and flower-and-vine scrolls. The deep red background of the scroll panels shows a remarkable color contrast to the whiteness of the porcelain body.

10. *Jar, flower-and-bird design. H. 16.0 cm. Middle Edo period.*
This jar is one of those pieces of pottery that were exported to Europe early in the eighteenth century and that have recently been brought back to Japan in considerable numbers. The design is somewhat more Imari-like than in the Kakiemon style, but the latter's lyricism can be seen in the conventionally drawn flowers and birds. The glaze is faintly tinged with blue.

This small jar is one of several that it is difficult to classify definitely as either pure Imari or pure Kakiemon in style. The difference between the two styles, together with the mutual influence each exerted on the other, may perhaps be seen in the noble grace, the clarity of the color scheme, and the typically Japanese mood of the design. These common features must have occurred naturally in the narrow valley in which Arita Sarayama was situated during the Edo period. The Imari style Kakiemon ware may well have been produced around the Kyōhō–Hōei eras (1704–35) in answer to current market demand.

11. *Dish, pine-bamboo-plum and bird design. D. 21.8 cm. Kakiemon Collection.*
To satisfy the European market, Kakiemon porcelain was required to be decorated with broadly asymmetric, continous designs, instead of more typically Japanese motifs in which right and left were equally balanced. This kind of design, with pine, bamboo, and plum and rock fanning out from the bottom of the dish was one typical Kakiemon style of decoration that suited European taste at that time.

12. *Dish, plum and quail design. D. 13.2 cm. Saga Prefectural Museum.*
Whereas quail are combined with millet in Plate 15 as an autumn design, this plum and quail design reflects the spring and shows the cultural influence of Japan's trade with Europe. Small, flowering autumn grasses were added later in the space to the left, and—to Japanese eyes, at least—this

detracts from the original balanced composition and gives the dish a certain asymmetrical feeling.

13. *Small deep bowl, poppy design. D. 9.8 cm.*
This pot may be called a cup. A large poppy design has been painted in a conventionalized manner adapted to European taste; it is divided into two separate compositions on the "front" and "back." The colors are even clearer and brighter than those of the preceding piece. The heart of the flower and the buds on the right and left show a novel style of depiction. A bright red accentuates the flower, and the blue and green also reveal the deft firing skill of the potter.

14. *Ewer, peony design. H. 15.3 cm.*
The Western-flavored design of this ewer shows peonies in European style around the sides together with extremely stylized peony sprays on the right and left shoulders of the pot. Compared with Kakiemon wares of the earlier period, the enamel colors are deeper and reflect a modification of design that was motivated by trade with the Netherlands.

15. *Octagonal bowl, millet and quail design and border band of halved floral roundels. D. 24.3 cm. Idemitsu Museum of Art.*
Kakiemon porcelains include the autumnal theme of quail designs. Examples of such pots may be found in both domestic and foreign collections. Indeed, quail designs were so widely disseminated that they began to be imitated at potteries in Germany, France, and England around the end of the eighteenth century. Pieces with millet and quail, flowering autumn grasses, and other such motifs were exported aboard Dutch trading vessels to meet the demand in Europe for Far Eastern porcelain.

Kendi type pitchers, which used to be made in Southeast Asia as well as in Europe as everyday ware, were also manufactured in Japan in pure Imari and Kakiemon styles. They were primarily for export, made in molds, mostly in gourd or ewer shapes, with Imari or Kakiemon style designs in overglaze enamels.

16, 17. *Gourd-shaped ewer, grape and squirrel design. H. 16.3 cm.*
Plates 16 and 17 show both sides of a Japanese style ewer form, decorated with a grapevine and squirrel design, painted in bright overglaze enamel colors.

The grape and squirrel motif was one of the typical designs of the Kakiemon style. The one on this ewer shows a particularly flowing style of brushwork, and its color effect is quite remarkable.

18. *Narrow-necked hexagonal bottle, rock and chrysanthemum design. H. 23.3 cm. Saga Prefectural Museum.*
This narrow-necked hexagonal bottle with its graceful underglaze cobalt and polychrome enamel decoration shows the Kakiemon style at its very best. The design is of delicately painted rock-and-chrysanthemum and rock-and-plum motifs extending around the six curving sides of the bottle. A similar example exists in the National Museum of Dresden.

19. *Narrow-necked square bottles, plum and chrysanthemum designs. Left: H. 21.5 cm. Kakiemon Collection.*
The shape of these bottles is based on Western silver and pewter forms; they were made to order for export. The sides are somewhat conventionally painted with plum and chrysanthemum sprays as well as with flowering plants of spring and autumn. Copies of such pieces were made at the Meissen porcelain factory.

20. *European copies of Kakiemon style polychrome overglaze enameled wares. H. 1.8–11.8 cm. D. 5.1–24.5 cm. Saga Prefectural Museum.*
Hizen porcelain began to be copied at Meissen, Germany, from around 1710. The Kakiemon style was copied especially frequently, and soon Kakiemon style pieces were being manufactured at the French royal pottery, and at Chantilly, at Chelsea and Worcester in England, and also in China at the end of the eighteenth century.

21. *Dish, grape and squirrel design. Meissen porcelain. D. 20.5 cm.*
Augustus II the Strong, king of Poland and elector of Saxony (1670–1733), was interested in Oriental porcelain. It was the Meissen ceramic factories under his rule that were the first in Europe to succeed in making true hard porcelain in about 1710, and marvelous imitations of the Kakiemon style were produced at Augustus's Meissen factory.

22. *Foliate bowl, pine-bamboo-plum design and border band with floral pattern. D. 19.1 cm. Idemitsu Museum of Art.*
The flower shape of this deep bowl, different in effect from earlier angular bowls, is very much in the European taste and may be seen to accord with baroque art forms. The rim of the bowl has been painted with iron (*fuchi-sabi*), while its inner lip has an undulating band of Indian style *yoraku* ("stringed jewels"). The outer sides have an extremely decorative but somewhat hard-looking design of rock and pine-bamboo-plum that extends around the body of the bowl.

23. *Jar, flower-and-bird designs in three panels. H. 25.9 cm. Idemitsu Museum of Art.*
This jar is a masterpiece, which, though flavored with a certain decorative European mood, retains the feeling and grace of the Kakiemon style. Bands of chrysanthemum flowers and blue floral scrolls divide the body of the jar into three panels, each of which show birds, peonies and chrysanthemums, and a rock. The decoration is impressive for its dynamic depiction of flower-and-bird subjects, while the milk-white background of the porcelain body has a polished warmth, and the drawing is fluently delicate.

24. *Lobed dish, rock and autumn grasses design. 21.2 × 18.4 cm. Middle Edo period. Tanakamaru Collection.*
This lobed shallow dish with its unusual form must be one of a set of five or ten, obviously made to special order in Japan. The design of rock and flowering autumn grasses, placed a little left of center, was probably inspired by an album of designs published during the middle Edo period. The inner surface of the dish is mostly undecorated, since it is to be used as a food vessel. The underside has been decorated with a flower-and-bird design in cobalt blue underglaze and shows the character *fuku* (good fortune) within a double-framed square.

25. *Bowl, chrysanthemum and peony design, openwork border of linked circles. D. 25.8 cm. Idemitsu Museum of Art.*
An order book preserved in the Kakiemon family records contains a sample sketch of a "bowl with openwork linked circles." The bowl in question was probably made in a mold, had the pattern of linked circles traced on the clay from a stencil, and the openwork pattern was then cut when the clay was leather hard. The fancy bowl pictured appears to have been intended for use as a cake dish. The center is decorated with a flowering chrysanthemum spray, surrounded on three sides by rocks and peonies.

26. *Pair of small-necked bottles, brushwood fence, flower, and bird designs. Left: H. 25.0 cm.*
The fine forms of these bottles with their long, thin necks (known as *tsurukubi*, or "crane necks," in Japanese) terminate in small mouths. The neck, from the shoulder to the mouth, has chrysanthemum flower petals executed in cobalt underglaze. The enamel decoration on the tall, gently curving body evokes the mood of a Zen painting in the way in which it combines a brushwood fence, a plum tree, and a bird.

27. *Bowl, plum and flowering grass design. D. 26.0 cm.*
This bowl is an important early example of Kakiemon wares. The porcelain clay of the pot indicates a stage prior to the milk-white porcelain body; iron specks have remained in the surface of the glaze, and the shape of the vessel is not regular. Later, overglaze enamel decorations were not painted on such poor clay, but during the early period of Kakiemon wares, this sort of unrefined clay body was used. Bowls of this kind have the inner surface painted with a chrysanthemum spray, or occasionally with a rock and chrysanthemum or rock and peony motif, and the outer sides with floral scrolls.

28. *Rectangular bowl, dragon and phoenix design. H. 5.0 cm.*
Hizen enameled porcelain includes many fine, but unexpected, pieces that cannot easily be classified either as purely Imari or purely Kakiemon in style. Among those masterpieces from the middle Edo period, made according to what is called "Shibuemon's taste," can be found some produced at the Kakiemon workshops in the Old Imari style (Shi-

buemon is thought to have succeeded as the sixth-generation Kakiemon potter, producing wares that harmonized form and design to perfection). This bowl, with its elaborately painted cloud and dragon and floral scroll designs, has particularly attractive and flowing brushwork and a great dignity.

29. *Incense burner, floral scroll design. H. 15.0 cm.*
From the middle to late Edo period, Kakiemon wares were made in a wide variety of shapes, with molded pieces appearing in addition to wheel-thrown shapes. Strangely shaped lidded vessels, incense burners, writing utensils, alcove ornaments, and so on were manufactured to answer domestic demand. This particular incense burner has been decorated in flowing brushwork with a blue underglaze floral scroll pattern featuring fine drawing and dotted here and there with red enamel.

30. *Incense burner, maple leaf and stream design; wagtail-shaped incense box. Left: H. 6.4 cm. Middle Edo period.*
The incense burner with a design of maple leaves afloat on a stream is decorated on the "front" and the "back" of the pot. The neat, compact composition of the design echoes the form of the modest-sized bowl with its three feet. It is painted in light colors accentuated by a small amount of red for the leaves. The waterbird-shaped incense box is somewhat different in age, but it is richly elegant despite its small size.

31, 32. *Footed rectangular dish, pine-bamboo-plum design. 21.8 × 9.5 cm.*
This dish is rare among surviving Kakiemon tableware and belongs to a complete set of five. It is an excellent piece from the middle Edo period showing the firmly established technique of press molding. It appears to be for use at ceremonial banquets on certain annual festive occasions, perhaps a dish for *ayu* (sweetfish). The rock and trees are executed in firm brushwork, and the border band of floral scroll and dragons chasing pearls is painted in flowing strokes. The exterior sides are decorated with sparsely scattered maple leaves. The dish was probably part of the tableware used by a daimyo's family.

33. *Dish, flower-and-bird design. D. 18.5 Gamachi Collection*
A dish identical in form and decoration exists in the collection of the Dresden Museum. The center shows a compact flower-and-bird design in underglaze cobalt alone. The border band of rock-and-plum-tree and rock-and-flowering-grasses, in cobalt underglaze blue and overglaze enamels, is divided into two separate compositions. The flowering grasses design in Western style is particularly interesting.

34. *Wall tiles, Repository, Nishi-Hongan-ji Temple. Each tile 24.7 cm. square. Early Edo period.*
Illustrated here are some of the tiles covering the lower part

of the walls in the Tenrinzō (repository of Buddhist scriptures housing a rotating bookshelf) of the Nishi-Hongan-ji temple in Kyoto. In an excellent state of preservation, the 312 tiles are painted alternately with dragons and mystic birds. The tiles are inscribed in ink on the back, "Made by Doi Genzaemon at Arita Sarayama, Nishi-Matsuura County," and also bear ink inscriptions of the names of their donors living in Saga Province. Whether they were made at a workshop directly affiliated to the Kakiemon kiln or whether Genzaemon—a man closely associated with the Sakaida family—commissioned them from the Arita Sarayama workshop remains an interesting subject of study. The Tenrinzō was built in 1677 in the time of the temple's fourteenth abbot, a fact that is important in dating the tiles.

35. *Tile, rock and bird design. 18.0 × 17.7 cm. Tanakamaru Collection.*

It was probably during the early Edo period that pottery and porcelain tiles began to be used for paneling in Buddhist sanctuaries, sutra repositories, bathrooms, and so on. There are some pottery tiles in the Oribe style, but in Hizen porcelain, tiles in the Kakiemon style appear to be dominant. The one shown here, unlike those shown in the preceding plate, is in genuine Kakiemon style. The fact that the porcelain body still has a slight amount of iron in it suggests a date even earlier than that for the tiles in Plate 34. A flower-and-bird motif has been dynamically drawn in a style reminiscent of the mural painting of the renowned Kanō school in the early Edo period. The rock is almost cubist in effect, while the peony and birds are executed in free-flowing brushstrokes. The feathers of the two birds, the peony flowers, and the veins of the leaves are drawn extremely elaborately; the blue of the rock and the red of the birds and flowers make a splendid color contrast.

36. *Two-tiered lidded box in the shape of an insect cage, flowing plant design. H. 19.5 cm.*

One- or two-tiered covered boxes in the shape of insect cages may be found among old Kiyomizu pieces from Kyoto. They may also be seen—although very rarely—among Imari wares. Covered boxes of this kind are generally classified by size into large, medium, and small types. The piece here is large. Opinions differ about the purpose of such boxes, some believing that they were used by noble young ladies of daimyo families. The insect-cage shape also exists in *maki-e* gold lacquer ware. The idea of making two-tiered boxes in porcelain was probably inspired by social trends of the mid-Edo period. This one has three legs, the lower tier being decorated with a series of morning glory flowers, and the upper tier with stylized floral scrolls. The lid is decorated with a net pattern, which is surmounted in relief by the tassels of the cords that come up the side of the box; the knot of the tied cords forms the box knob. This form could easily sag or collapse in firing; it was only as a result of long training and skill that this pot came out of the kiln so nicely.

37. *Jar, flower-and-bird design. H. 28.7 cm.*

Covered jars of the *jinkō tsubo* form are numerous among *sometsuke* and enameled Kakiemon pots. They include some that are richer in elements of pure Imari style than of Kakiemon style, making it difficult to classify them as either of these. Even a pot registered by the Japanese government as an Important Cultural Property contains various problems. Clues for the classification of such wares, therefore, should be sought, perhaps, in the decorative compositions and particularly in the contrast between the positive and negative areas of the design; in the treatment of the overglaze enamel decoration on the porcelain body; in color tones and color combinations, etc. The design on this jar is not divided into separate sections but is one composition, and the green of the rock and red of the flowers show deep tones, all characteristics that lead to its classification as Kakiemon.

COBALT UNDERGLAZE DECORATED PORCELAIN

Sometsuke is the name given to cobalt blue underglaze decorated wares; these have a charm that the Japanese, with their special sensitivity for color, have likened to indigo dyeing. In contrast with the brilliant enameled porcelain discussed so far, *sometsuke* porcelain displays a modest, quiet beauty.

38. *Sometsuke vase, flower-and-bird and scroll design. H. 28.5 cm. Saga Prefectural Museum.*

This vase may have been made at Mukurodani-gama in Nangawara-yama, Arita, a collateral kiln of the Kakiemon workshop. It is painted on one side with rock and pine-bamboo-plum design and on the opposite side with rock, bamboo, and sparrows. The tall, slender neck has a complex design of tendril scrolls and other motifs. The cobalt pigment used has quite a lot of iron in it, giving a dark dull tone. The decoration is typical of Nangawara Sarayama, though it contains many Imari style elements.

39. *Large sometsuke bowl, rock and heron design. H. 16.7 cm, D. 42.0 cm. Tanakamaru Collection.*

After the Bunka-Bunsei eras (1804–30), when domestic demand for "blue-and-white" porcelain increased, Kakiemon kilns also manufactured large, deep bowls and other such popular pieces. This example has the interior surface decorated in three bands: a rock and heron design at the center, a landscape with fishing nets drying in the middle, and rock-and-bamboo, rock-and-plum, and bird motifs in the top band. The linked scroll units on the exterior are drawn with powerful brushstrokes.

40. *Square sometsuke dish, hydrangea design. Side 22.7 cm. Tanakamaru Collection.*

The decoration is painted in a clear-toned blue, evoking the freshness of early summer. An identical design is to be found in the *Ehon tsūhō shi* (see Plate 3 caption). The diagonal composition in the approximately square panel shows a fine balance of positive and negative areas. The pot thus com-

bines utility with beauty to fulfill its function as a "cake" dish. The border is decorated with three bands of scrolls. The back bears the *sometsuke* mark "Saka Kaki," an abbreviation of "Sakaida Kakiemon." Apparently the bowl was made at the Kakiemon kiln around the Meiwa era (1764–72), at the turning point of the middle and late Edo periods.

41. Sometsuke *fan-shaped lidded box, peony scroll and phoenix design. 23.2 × 15.9 × 6.0 cm. Kakiemon Collection.*
A few years ago I saw a similar *sometsuke* fan-shaped lidded box at The Hague Municipal Museum. Perhaps such boxes were made for export. They are valuable rarities, different in form and style from pure Imari work. Fine pieces of *sometsuke* have, in a sense, a profound, noble beauty that is not to be seen on enamel-decorated porcelain.

The blue lines and areas of the spreading peony flowers and phoenix are harmonious in tones and rhythms. The brushwork is fluent and accentuated. The potter's finesse is extended to such details as, for example, the converging ribs of the fan around the pivot, which were cast in relief.

42. Sometsuke *incense burner, deer and tree design. H. 12.2 cm. D. 20.0 cm.*
Excellent pieces with designs of deer exist among enameled as well as "blue-and-white" porcelain wares. Unlike Imari and Nabeshima *sometsuke*, Kakiemon *sometsuke* ware is characterised by an idyllic tenderness. The sides of the incense burner here are painted with mountains and fields in spring, with fragrant young green pines and leaping deer. The body of this pot is thus like a scroll painting that is unrolled before one's eyes. Floral scrolls decorate the mouth, while the bottom of the interior is unglazed.

43. Sometsuke *dish, ayu (sweetfish) design. D. 19.3 cm. Tanakamaru Collection.*
This is a summer motif executed in free, light brushwork, its depiction in blue monochrome being pure and fresh like a Zen ink painting. The design shows an exceptionally dynamic composition. The dish was made at a kiln affiliated directly with the Kakiemon family and is different in workmanship from products of the collateral workshops. It is one of a set of similar dishes but is sufficiently worthy of being appreciated independently.

44. Sometsuke *dish, maple and deer design. D. 18.0 cm. Gamachi Collection.*
This decoration in typical Kakiemon style is one found on many *sometsuke* shards unearthed at old kiln sites on the hill behind the workshop of the present-generation Kakiemon. The poses of the deer are interestingly similar to those of the piece in Plate 42. A picture of maples and deer is illustrated under the title "Kasugano" (Kasuga Field) in the picture book *Ehon tsūhō shi* (see note to Plate 3). It is a motif full of poetic associations and is frequently found in Japanese art. The rim painted in iron effectively accents the simple blue decoration.

45. *Dish, Hotei and autumn grass design. D. 24.8 cm. Tanakamaru Collection.*
Around the middle of the Edo period, woodblock-printed picture and copy books were published throughout the country. Many of the pictures in such books found their way into ceramic ware decoration. The Hotei figure here may well be an example of this borrowing.

46. *Dish, sparrow and bamboo design. D. 21.4 cm. Gamachi Collection.*
The decoration on this dish, leaving ample areas of the beautiful milk-white porcelain body, shows a composition typical of the Kakiemon style.

47. *Foliate bowl, flower and butterfly design. D. 25.0 cm. Saga Prefectural Museum.*
The molded bowl displays a precise, dignified form, while the floral scroll design in the center medallion of the pot is particularly impressive.

48. *Figurine of standing woman. H. 57.3 cm.*

49. *Figurine of standing woman. H. 35.5 cm.*

50. *Figurine of standing woman. H. 22.4 cm. Idemitsu Museum of Art.*
Polychrome overglaze enameled porcelain ware from Hizen includes quite a few figurines of women, children, actors, and other figures. Female figures among them in the Kakiemon style are different from those in the purely Imari style, being characterized by faces with elegant, quiet expressions similar to the masks used in the Nō theater. Kakiemon style female figures include ones made in the same mold, but whose clothing is decorated with different designs.

51. *Octagonal* mukōzuke *dishes, grape and squirrel design. Left: 7.5 cm. Tanakamaru Collection.*
No other example of the numerous Kakiemon food bowls for everyday use display the characteristics of the ware as well as these bowls. The milk-white porcelain body is flawless, and the enamel decoration harmonizes with the luminous porcelain.

THE KAKIEMON TRADITION TODAY
The present head of the Kakiemon workshop, Kakiemon XIII, has tried to honor the tradition of design and technique that is his heritage, while instilling a sense of modernity into the enamel decoration. Both he and his father tried to re-create the luminous milk-white porcelain body, the techniques of which had been lost for some time. Kakiemon XIII also experiments with novel designs based on his studies and sketches of wild plants.

52. *Dish, flowering grass design, by Kakiemon XIII. D. 45.6 cm.*
Edo period enameled Kakiemon pieces decorated with sprays of wild plants are very rare. Kakiemon XIII knows

that large bowls with a milk-white porcelain body frequently fail in the firing, yet he is daring enough to experiment in this field. A man of less rigid sobriety than his father, he likes to play the *samisen* and sings amorous ballads when drinking. It is this sort of mind that probably gives birth and life to such ideas as the generous design on this dish.

The design, with its ample spacing, recalls a bundle of flowering grass placed on a large lacquer ware tray, and leaves much unstated. Particularly notable is the balance between the areas of the enamel decoration and the beautiful milk-white porcelain body.

53. *Large dish, flowering grass design, by Sakaida Masashi.*
 D. 40.3 cm.

The artist, who is the only son of Kakiemon XIII, is still young; for this reason, perhaps, he can work in a liberal and unrestricted style. Precisely because he belongs to a strongly conservative family, I look forward to the development of his designs.

The artist learned the orally transmitted secrets of overglaze enamel recipes from his grandfather. Being modest, he follows in the wake of his father and treats wild plants as his motifs. This design of foxtail (*Setaria virides*) flowering on the roadside, though as yet unrefined, is full of youthful rhythm.

Kilns of Arita Sarayama

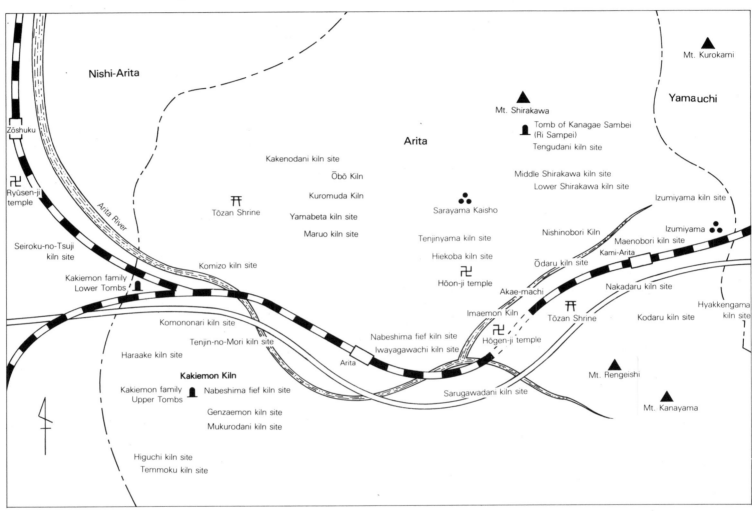

Nishi-Arita

Mt. Kurokami

Yamauchi

Mt. Shirakawa

Tomb of Kanagae Sambei
(Ri Sampei)
Tengudani kiln site

Arita

Zōshuku

Kakenodani kiln site

Ōbō Kiln

Middle Shirakawa kiln site
Lower Shirakawa kiln site

Izumiyama kiln site

卍
Ryūsen-ji
temple

Kuromuda Kiln

卉
Tōzan Shrine

Sarayama Kaisho

Izumiyama

Yamabeta kiln site

Nishinobori Kiln

Seiroku-no-Tsuji
kiln site

Maruo kiln site

Maenobori kiln site

Tenjinyama kiln site

Kami-Arita

Komizo kiln site

Hiekoba kiln site

Ōdaru kiln site

Kakiemon family
Lower Tombs

卍
Hōon-ji temple

Nakadaru kiln site

Komononari kiln site

Akae-machi

卉
Tōzan Shrine

Hyakkengama
kiln site

Tenjin-no-Mori kiln site

Imaemon Kiln

Kodaru kiln site

Haraake kiln site

Nabeshima fief kiln site

卍
Hōgen-ji temple

Kakiemon Kiln

Iwayagawachi kiln site

Arita

Kakiemon family
Upper Tombs

Nabeshima fief kiln site

Mt. Rengeishi

Genzaemon kiln site

Sarugawadani kiln site

Mukurodani kiln site

Mt. Kanayama

Higuchi kiln site
Temmoku kiln site